IMAGES
of America

DETROIT'S CORKTOWN

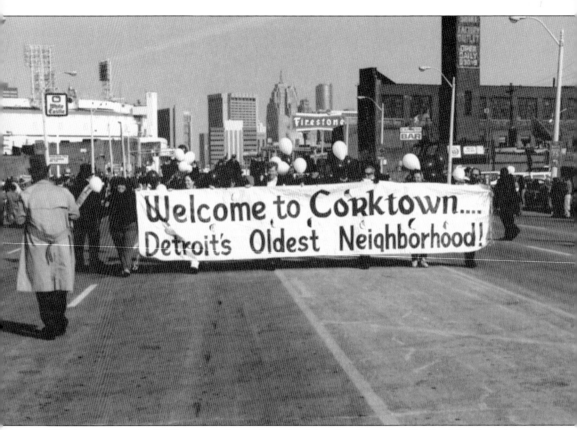

The banner says it all. The annual parade and celebration honoring St. Patrick takes place on Michigan Avenue on the Sunday preceding St. Patrick's Day, and it has become Detroit's answer to Mardi Gras. Thousands of people crowd the streets and saloons of Corktown to watch the parade and to celebrate being Irish, even if only for one day. It has become Corktown's gift to the whole region.

On the cover: This is the corner of Bagley Street and Twentieth Street in the early 20th century. (Courtesy of the Walter P. Reuther Library, Wayne State University.)

IMAGES
of America

DETROIT'S CORKTOWN

Armando Delicato and Julie Demery
for the Worker's Rowhouse Museum

ARCADIA
PUBLISHING

Published by Arcadia Publishing
Charleston SC, Chicago IL, Portsmouth NH, San Francisco CA

Printed in the United States of America

Library of Congress Catalog Card Number: 2007932661

For all general information contact Arcadia Publishing at:
Telephone 843-853-2070
Fax 843-853-0044
E-mail sales@arcadiapublishing.com
For customer service and orders:
Toll-Free 1-888-313-2665

Visit us on the Internet at www.arcadiapublishing.com

*This book is dedicated to the residents and friends of Corktown,
past, present, and future.*

CONTENTS

ACKNOWLEDGMENTS

We are grateful for the support and enthusiasm of many people who were approached for assistance in finding images and information about Corktown's past and present. This book is a tribute to them as well as to all the many people and institutions that have worked to make Corktown thrive over the years.

A special recognition and thanks go to the following: Mary Luna Abbott, Ann Aldrich, Rev. Matthew Bode, Charles and Mary Brincat, Julie Calligaro, Grace Caruana, Tom Coles, Steven Deeb, Margaret O'Leary Demery, Fr. Thomas Doyle, Tom Featherstone and the Walter P. Reuther Library at Wayne State University, Debbie Goldstein, Mike Hauser, Dr. Meghan Howey, Brian Hurttienne, Ed Marman, Tim McGahey, Tim McKay and the Greater Corktown Development Corporation, Sr. Maureen Mulcrone, Mary O'Connell, Jim O'Kelly, Kathleen O'Neill, Mary Kay Scott, Victor Sultana, Margaret (Peggy) Walsh, Marie Wilke and the Archdiocese of Detroit Archives, Ed Woodlan, and Rosalinda Ybarra.

INTRODUCTION

After over a century of existence as a small French outpost on the frontier, Detroit began to grow and develop in the 1830s with the introduction of steamboats on the Great Lakes, railroads, and the completion of the Erie Canal. The discovery of extensive mineral resources in the Upper Peninsula of Michigan and the tremendous amount of lumber from the forests of the new state resulted in explosive growth. When Horace Greeley made his famous suggestion to young Americans to "go west young man," he was referring to Michigan and the Midwest, and people began to take his advice.

From 2,200 inhabitants in the census of 1830 to 9,102 in 1840, the rate of growth was tremendous. The rural village of French-speaking farmers and traders was soon to be swamped by incredible growth that would transform it into a modern industrial giant. Detroit was on its way to becoming a beacon to the rest of the world, offering opportunities to escape from poverty and oppression. The stage was set for Detroit to become the multicultural composite it is today.

The first large group of immigrants to reach Detroit was the Irish, escaping the oppressive political, social, and economic conditions in their homeland. Detroit was not to be the largest settlement of the Irish diaspora. Far larger numbers settled on the East Coast while many filtered further west to Chicago and the mining areas in the mountain states.

Detroit, however, was a favored destination for thousands of Irish, as it would become for many thousands of others, because of its relative lack of hostility as well as the potential for economic improvement.

Detroit's French Catholic origins meant that there was less religious discrimination faced by the many Irish Catholics. The frontier spirit discouraged the growth of an elite upper class, and opportunities seemed endless for people that embraced a strong work ethic.

The first Irish immigrants settled on the lower east side of the city and in the downtown area. By 1840, the French ribbon farms to the west of the city were sold by the Cass and Woodbridge families for development. The neighborhood known as Corktown quickly became home to more and more of the new Detroiters from Ireland. Proximity to the river and the growing industries there as well as the easy access to downtown were important factors in the development of the neighborhood. By the 1850s, the eighth ward of Detroit had become predominantly, though not exclusively, Irish, and the cultural institutions they founded became the center of a vibrant working class community. By the end of the Civil War, the German population of Detroit, while centered on Gratiot Avenue on the east side of the city, began to spill over into Corktown as well.

The Catholic and Protestant churches, founded by the new Detroiters, became the foundation of the neighborhood. Retail, industry, and entertainment centers also provided the inhabitants of Corktown with the means to live the American dream.

By the early 1900s, the Irish inhabitants had begun to spread throughout the city and suburbs. New immigrants, especially from Malta and Mexico, began to settle in Corktown, adding their own imprint on the neighborhood. Ethnic diversity developed as African Americans and southern whites and other immigrants joined them.

By the mid-20th century, new problems developed for Corktown. The city's prosperity meant that many middle-class residents were able to move up to newer and bigger homes in the outlying neighborhoods of the city and suburbs. Corktown was becoming a neighborhood for the poor and neglected. By the 1950s, the city condemned large portions of the neighborhood in order to construct the John C. Lodge and the Fisher Freeways. Much of the rest of Corktown was razed in order to create an industrial park despite determined opposition of the citizens. As air travel and the new interstate highways became more popular, the train station lost traffic. Even the stadium lost the Detroit Lions and its name was changed to Tiger Stadium to reflect its only tenant. Vacant lots became parking lots to serve the stadium while numerous bars opened to serve the sports fans rather than the residents. As the century wound down, the stadium was abandoned when the new Comerica Park was opened downtown and the Michigan Central Railroad station sat empty and forlorn at the western edge of the community. The future of Corktown seemed grim.

Fortunately, the grand old neighborhood was able to resuscitate itself. The churches of the neighborhood, the remaining neighborhood businesses, and organizations such as the Gaelic League, Maltese Federation, and the Greater Corktown Development Corporation have worked to infuse the neighborhood with energy. New businesses, restored homes, and creative reuses of older buildings in the community have given Corktown a renewed determination to thrive in its third century. The neighborhood's Irish roots have continued to survive through the efforts of the churches, the St. Patrick's Day parade that draws thousands of Detroiters to celebrate each year in March, the continued presence of the Gaelic League, and the Irish saloons that have survived. These institutions continue to serve as a draw to bring people back to the neighborhood.

An important development is the restoration of a building on Porter Street that is the Worker's Rowhouse Museum, which honors the immigrants and other residents of Corktown who have made the community charming and humane over its long history. While the past is respected and homage is paid to those who have created this community, the future reflects a synergy of respect for the past and drive to the future.

One

EARLY HISTORY

Following the opening of the Erie Canal in 1825, Detroit was no longer isolated on the frontier. The fertile lands of Michigan and the discovery of natural resources in the Upper Peninsula made Detroit a logical place for industrial and commercial growth. As settlers poured into the city, the boundaries were pushed east, north, and west. By the 1830s, the farms in the area known as Corktown were subdivided. The growing population of Ireland combined with the political oppression and increasing poverty of most of its people spurred many of its citizens to migrate. Although Corktown was not the first Irish neighborhood in Detroit, it rapidly became the center of Irish life. By the 1840s, Most Holy Trinity Church was moved on rollers to its present location to serve the growing population. The present church was built as a shell around it and, upon completion, the old building was removed from the interior of the new one. Soon after, other churches—Catholic, Episcopal, Lutheran and other Protestant parishes—were built to serve the increasingly diverse population of Corktown. Germans, both Catholic and Protestant, also moved into the neighborhood in large numbers.

From the beginning, a distinct characteristic of Corktown was the working-class nature of its population. Although some of Detroit's gentry lived along Fort Street during the 19th century, and some community leaders lived in grand houses along Trumbull Avenue and other streets, the majority of Corktown residents worked in the factories, on the docks, or in small retail establishments. Corktown in the 19th century was a neighborhood of hardworking people, mostly immigrants or their children, who sought to achieve the American dream.

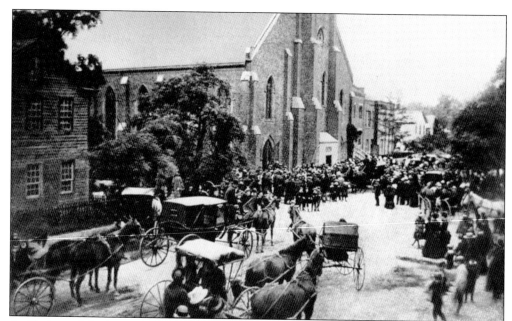

As Corktown's Irish population grew, Most Holy Trinity Church was moved on rollers in 1849 to its present site on Porter Street and Sixth Street. During its history, it has served as a hospital for plague victims, a school, and a community center for the neighborhood. It has provided the community with spiritual, social, and financial assistance when needed. Pictured here is a crowd gathered for a funeral in the late 1800s. (Courtesy of Deborah Goldstein.)

Most Holy Trinity Church opened a school by 1850. The church ran a school for boys and a school for girls. This building, on Porter and Seventh Streets, was begun in 1858 as the girls' school with a boys' school down the street. The building continued to serve the parish until it was demolished in the 1950s for the urban renewal district. (Courtesy of the Walter P. Reuther Library, Wayne State University.)

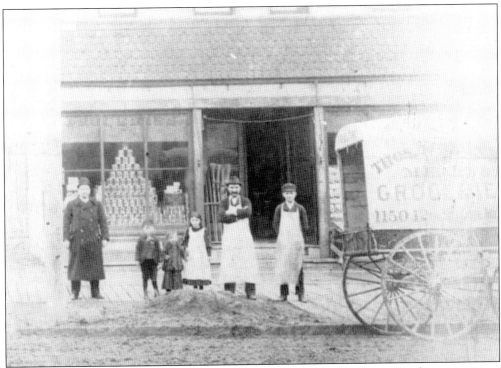

FOREIGN PASSAGE AGENCY AND OFFICE,
FOR THE TRANSMISSION OF MONEY TO
GREAT BRITAIN, IRELAND, FRANCE AND GERMANY,
R. R. ELLIOTT, DETROIT, MICHIGAN.

N⁰ 3

(See Over.)

PERSONS DESIROUS OF BRINGING OUT THEIR
FRIENDS FROM THE OLD COUNTRY,
Can make Arrangements for their Passage at this Office.

R. R. ELLIOTT, Detroit, Mich.

Detroit, June 9 1870

Received from Miss Donovan

Ten Dollars, being for a Draft payable on the

ROYAL BANK OF IRELAND

for £2 Sterling, favor of Michael Barry

RICHARD R. ELLIOTT,

Issued by me

per

£2 $10

Sending money back home to Ireland was a sacred duty of the Irish immigrants, either to finance the passage of a loved one to America or to ease the burden of poverty back home. The Richard Elliot office managed both remittances of money and the travel to America for relatives of Detroit's Irish. Shown above is a $10 draft sent by Julia Ann Donovan to her uncle Michael Barry of County Kerry, Ireland.

Arriving in 1880 from Castlebar, County Mayo, Ireland, Thomas Eugene Maloney set out to support his family of 11 children. He is pictured here with his arms folded beside three of his children who, from left to right, are Joseph, Frances, and Maybelle. The other two gentlemen are unidentified.

Ann Ryan Maloney and her husband, David Maloney, from Castlebar, County Mayo, Ireland, are seated during the 1890s in front of the 384 Seventeenth Street Corktown home of their daughter Maria, her husband Michael Kelley, and their 10 children. Shown below is a copy of the deed to the house. Notice that the original owners of the property were the Potowatomi Indians.

BRIEF HISTORY OF OWNERSHIP OF 382 17TH STREET

OWNED BY MICHAEL J. KELLEY

TAKEN FROM ABSTRACT DEED FOR #309 OF THE STANTON FARM -

FROM THE POTOWATAMI INDIANS TO
THE CHEVALIER
FROM THE CHEVALIER TO REVEREND GABRIEL RICHARD
FROM REV. RICHARD TO MONSIEUR LASSELLES
FROM MONSIEUR LASSELLES TO D. SOUTHERLAND
SOUTHERLAND TO ROCKELMAN 1868
ROCKELMAN TO JOHN KROBECK
1870 J. KROBECK TO JOSEPH KUHN
1872 JOSEPH KUHN TO JOHN RIEDEL
1878 JOHN RIEDEL TO JOHN MIESEL
1880 JOHN MIESEL TO JOSEPH KUHN
1884 J. KUHN - INSOLVENT - TO EDWARD GOTT
JUNE, 1884 - OFFERED AT PUBLIC AUCTION FOR DEBTS OF J. KUHN TO
ANTHONY GROSFIELD AND PETER SCHULTE
1887 QUIT CLAIM GROSFIELD TO P. SCHULTE
1888 PETER SCHULTE TO JOSEPH TOTTEN
J. TOTTEN BACK TO P. SCHULTE - 1888
PETER SCHULTE, WIDOWER TO MARY AHRENS DEC. 1892
MARY AHRENS TO JAMES BRENNAN AND MICHAEL KELLEY
ON DECEMBER 24, 1892.

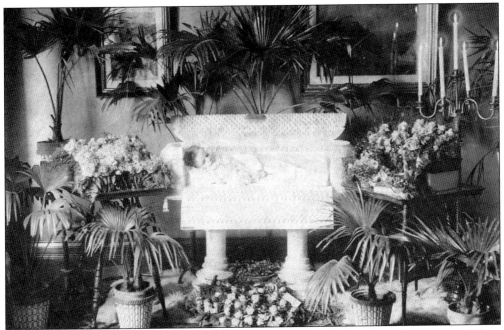

Tragically, many children died in infancy during the 19th and early 20th centuries. Many families, including that of Thomas Moloney, suffered the loss. Most wakes took place in the home where family and neighbors gathered for consolation. Children were buried in white caskets to recognize their innocence.

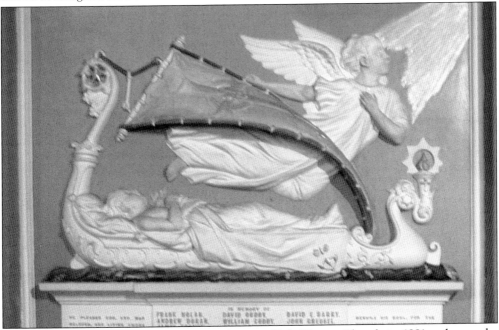

This white bronze tablet was erected inside Most Holy Trinity Church in 1881 to honor the memory of 17 altar boys and other members of the congregation who drowned in the Detroit River while on a parish outing on the pleasure boat *Mamie*, on July 22, 1880. (Courtesy of the Walter P. Reuther Library, Wayne State University.)

Mary Ellen Sullivan, like many of the young women that grew up in Corktown, decided to dedicate her life to God and became a member of the Order of St. Joseph. This high school graduation picture, taken in 1892, was her last in "civilian" clothes. She taught at parochial schools for many years.

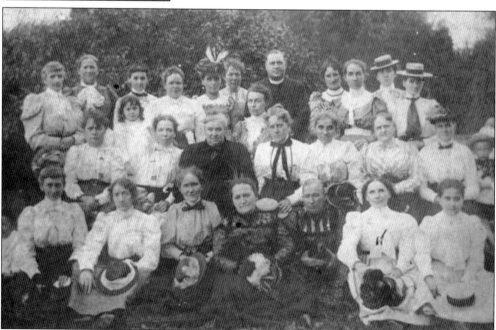

By the 1890s, many Irish immigrants in Corktown had established themselves economically and socially and turned their attention to improving the plight of the less fortunate. These women were members of the Most Holy Trinity's Ladies Christian Benevolent Association (LCBA) and sat for a portrait at their church picnic.

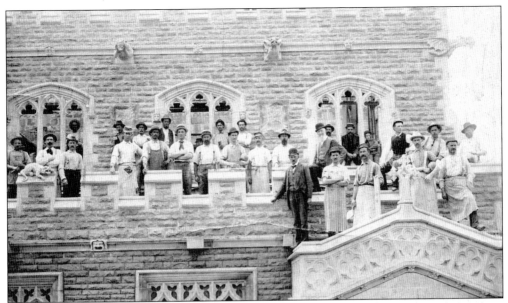

Finished in 1892, Trinity Episcopal Church is a perfect replica of a rural Gothic church in England. The founding publisher of the *Detroit News*, James Scripps, nurtured the Episcopalians of northern Corktown and nearby Woodbridge to produce this fabulous neo-Gothic structure. It is faithful to its origins, even with the gargoyles protruding from the roof and the superb stained-glass windows that magnificently light up the interior. (Courtesy of the Reverend Matthew Bode.)

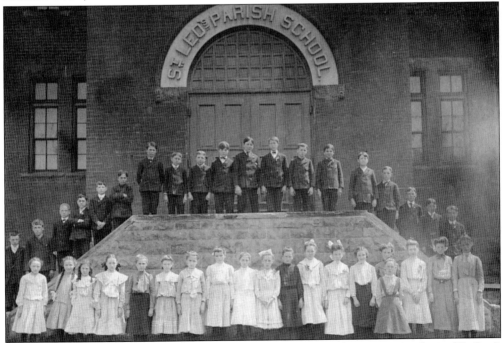

Although not geographically in Corktown, many Corktown residents were members of St. Leo's parish on Grand River Avenue. These students of the parish school in the 1890s are posing for their class portrait with all 48 class members dressed up for the occasion.

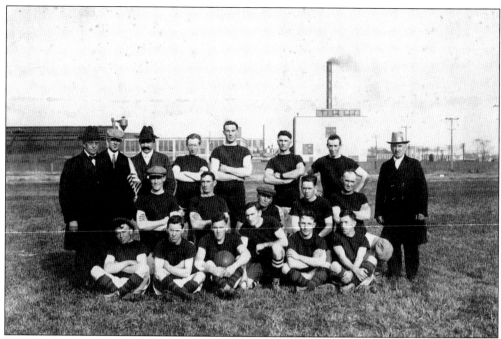

Young men have always enjoyed playing sports in their leisure time. This photograph is of a soccer team comprised of young Irish Corktowners. Included in the portrait, on the far left, is Mayor Johnny Smith, a loyal supporter of his favorite team.

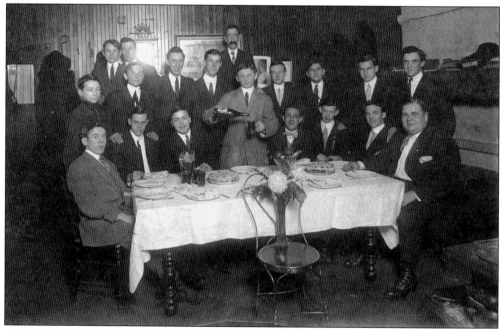

During the Victorian era and well into the 20th century, young men sought to belong to clubs that would be both fraternal and uplifting. These men are gathered for a formal evening of fellowship. The empty chair symbolized those that could not be present, especially those that were deceased. The symbolic drink is being poured for the missing member.

Given the extensive use of lumber as a building material in Corktown, the danger of fire was always a threat. Among the early firehouses was this one at the corner of Sixth Street and Baker, now Bagley Street. It was replaced in the 1920s by the modern firehouse that has since been turned into a law firm's office.

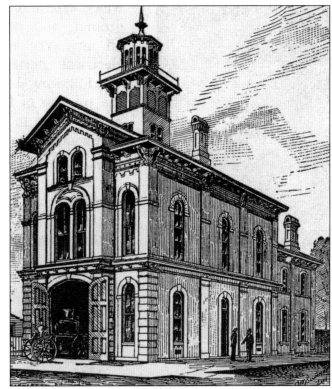

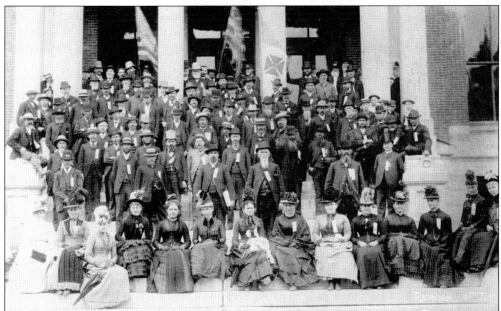

The Grand Army of the Republic (GAR) was a veteran's organization founded by men who had fought in the Union army during the Civil War. Cornelius O'Dwyer, a native of Corktown born to Irish immigrants, was prominent in forming the Detroit branch of the GAR and the local chapter of the Ancient Order of Hiberians, an Irish society dedicated to the preservation of Irish culture in America. (Courtesy of the Walter P. Reuther Library, Wayne State University.)

Prior to 1896, the northwest corner of Michigan and Trumbull Avenues was a hay market. Bennett Park was named after a former catcher who lost both legs in a train accident. In 1911, the expanded ballpark was renamed after its owner, Frank Navin. From 1938 until 1960, the stadium was known as Briggs Stadium, named after another owner, Walter Briggs. It became Tiger Stadium in 1961 when the Detroit Lions moved to Pontiac. (Courtesy of the Walter P. Reuther Library, Wayne State University.)

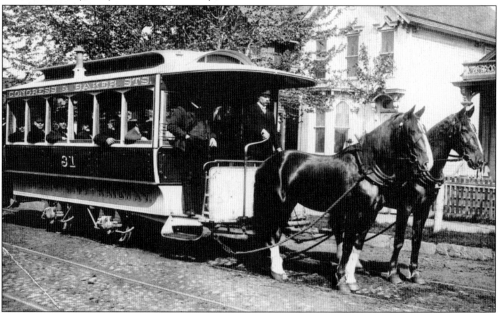

On August 3, 1863, the first street railroad was initiated in Detroit on Jefferson Avenue. Corktown was served by several of these horse-drawn streetcars. This streetcar is on the Baker line, which was the original name for Bagley Street. Other streetcars ran on Michigan and Trumbull Avenues. They transported workers and shoppers to downtown and to industries along the riverfront. (Courtesy of Mary Luna Abbott.)

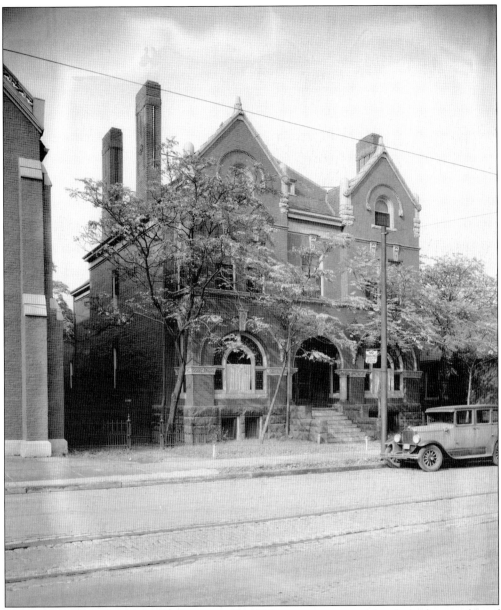

While most of the homes in Corktown in the 19th century were made of wood, a number of buildings were constructed of brick or stone. This beautiful Victorian structure is the rectory that was built to house the priests that served Most Holy Trinity Church. It is still in use over a century after it was built. (Courtesy of the Walter P. Reuther Library, Wayne State University.)

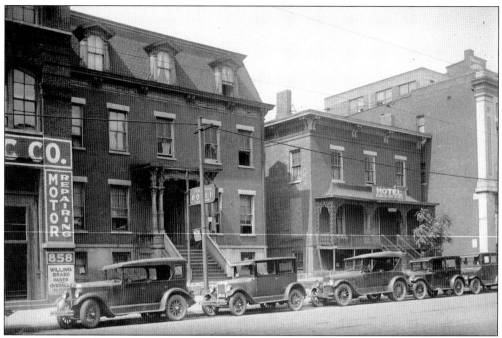

This streetscape on Fort Street shows a busy commercial center along Corktown's southeastern border. None of these buildings survived the rush to increase the space devoted to commerce and industry in the 1920s. (Courtesy of the Walter P. Reuther Library, Wayne State University.)

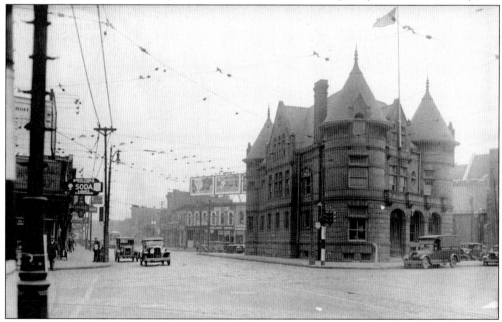

The eighth ward of the city of Detroit got its first police station on Trumbull Avenue in the 1840s. This imposing castlelike building was erected on the southeast corner of Michigan and Trumbull Avenues in the late 19th century and served the community until the 1930s when it was demolished in order to widen Michigan Avenue. (Courtesy of the Walter P. Reuther Library, Wayne State University.)

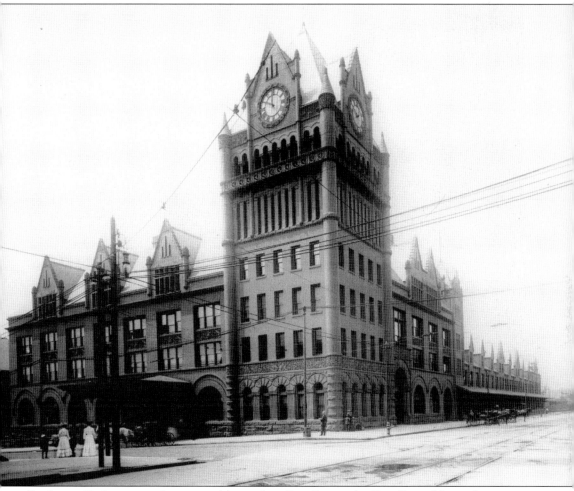

Bordering Corktown on the east and located on Fort Street, the Fort Street Union depot was built in 1893 and served the Wabash, Pere Marquette, and Pennsylvania Railroads. Freight from these lines and from the Detroit River docks was shipped throughout the state and the Midwest. Constructed in the Richardsonian Romanesque style, the building continued to serve commuter passengers until it was demolished in the 1970s to make way for the Wayne County Community College campus.

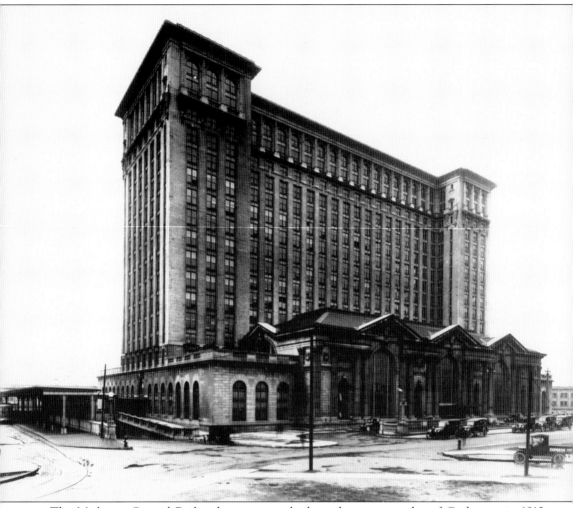

The Michigan Central Railroad station was built at the western edge of Corktown in 1913 with the expectation that Detroit's downtown would eventually expand and replace the old neighborhood. This beautiful building was designed by the same firm that designed Grand Central station in New York and has dazzled travelers for many decades. The Beaux-Arts building is grand both in its exterior and interior. In 1919, the buildings that separated it from Michigan Avenue were demolished to create Roosevelt Park.

Two

1900 TO 1960

The early 1900s ushered in a period of fantastic growth and fundamental change for Detroit and Corktown. The city grew rapidly as an industrial and commercial center during the post–Civil War era. With the advent of the automobile industry, of which Detroit was to be the center, the city attracted people from throughout the world to share in its seemingly limitless prosperity. Corktown saw many of its citizens move on to the newer neighborhoods in the growing city. While many Irish remained, the neighborhood became home to thousands of new immigrants from Malta and Mexico and other parts of the world. Southern migrants, African Americans and Appalachian whites, also arrived, hoping to share in the city's prosperity.

The community's growing diversity reflected that of Detroit. Corktown remained a solid working-class neighborhood characterized by an optimistic faith in its traditional values. However, by the end of World War II, there were ominous signs that change was coming. Corktown was seen by many of Detroit's leaders as a potential slum and ripe to emerge as a commercial and light industrial center. The decline of the sports stadium, the railroad stations, and the industrial areas along the river seemed to signal the changing destiny of the neighborhood. Urban renewal in postwar America usually meant demolition. As one era was ending, the residents of Corktown geared up to fight to preserve their community.

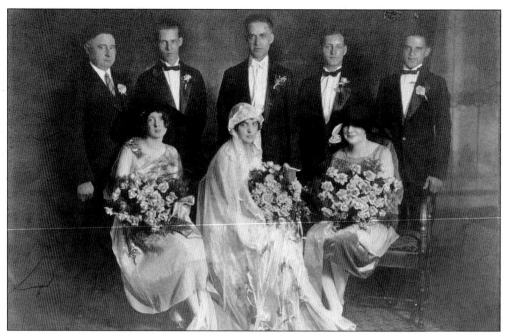

For every ethnic group and neighborhood, there are rituals that mark people's progress through life. An especially happy time is the celebration of marriage. This young Irish Corktown couple had a traditional formal wedding portrait made at a studio on Michigan Avenue after their ceremony but before the formal lunch and evening reception popular during most of the 20th century.

One of the things that all the various ethnic groups in Corktown have shared is the love of celebration. The wedding of Mary Tabone and Charles Brincat began with the marriage ceremony at St. Paul's Maltese Catholic Church in the morning and continued throughout the day and the late evening with dinner and dancing. Note how children were welcome to participate in these celebrations. (Courtesy of Charles and Mary Brincat.)

This picture was taken at Frank Agius's Corktown home in May 1920. It shows a group of Maltese immigrants at an Americanization meeting provided by Ford Motor Company to prepare them for American citizenship. (Courtesy of the Bentley Historical Library, University of Michigan.)

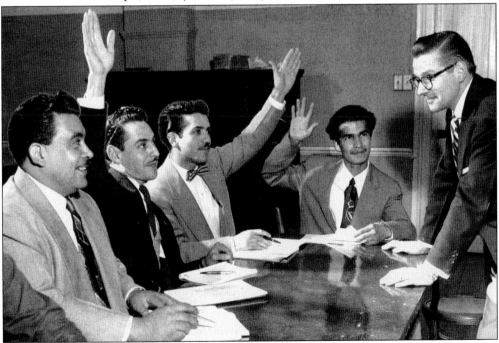

These young men from Puerto Rico learned English through the auspices of the YMCA. They, like so many others, began their Americanization in Corktown. (Courtesy of the Walter P. Reuther Library, Wayne State University.)

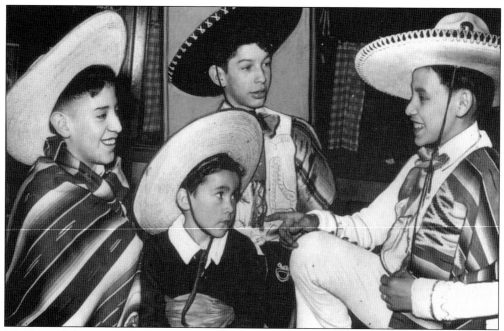

Members of the growing Mexican community of Corktown in the 1950s were encouraged to be familiar with their heritage. Pictured, from left to right, Henry Carabajal, Emilio Della Torre, Joe Alvarez, and Henry Chavez are learning traditional Mexican folk dances. (Courtesy of Mary Luna Abbott.)

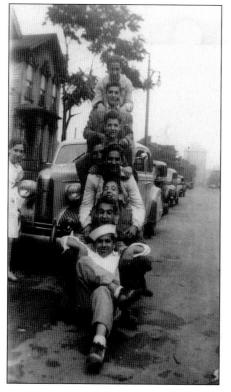

In the early 1940s, the neighborhood gang clowns around during leave time from the war. These young men, who are friends of Victor Sultana, are in the armed forces or expecting to leave soon for training. The bonds of friendship formed in their youth have remained firm through the years. Many of these men continue to have reunions in the 21st century. (Courtesy of Victor Sultana.)

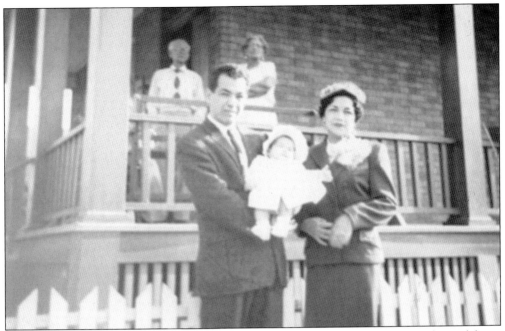

Henry and Carmen Ybarra proudly show off their new daughter, Rosalinda, as they celebrate her baptism at Most Holy Trinity Church. They are standing in front of their home on Beech Street while Rosalinda's grandparents Francisco and Maria Ybarra watch from the front porch. (Courtesy of Rosalinda Ybarra.)

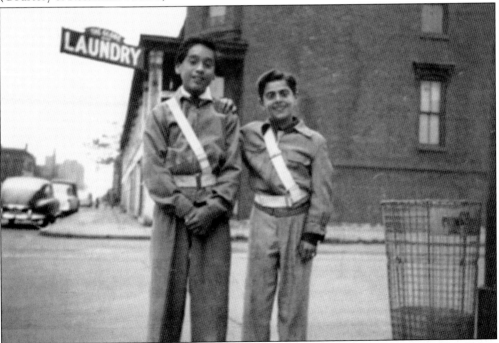

These safety boys are on duty at the corner of Sixth and Porter Streets in 1955 outside of Most Holy Trinity School. On the left is Torrance Abraham and on the right is Manuel Costello. (Courtesy of Rosalinda Ybarra.)

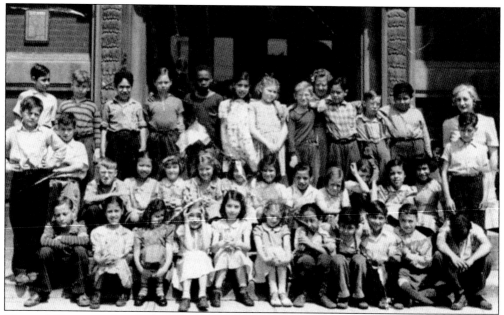

These children posed with their teacher outside the Houghton Elementary School in the late 1930s. One young man, Eugene Lipscomb (fifth from the left in the third row), grew up to become a professional football player with the Baltimore Colts. The teacher, Miss Brody, taught 37 fifth graders who reflected the diversity of the Corktown community in the 20th century. (Courtesy of Mary Luna Abbott.)

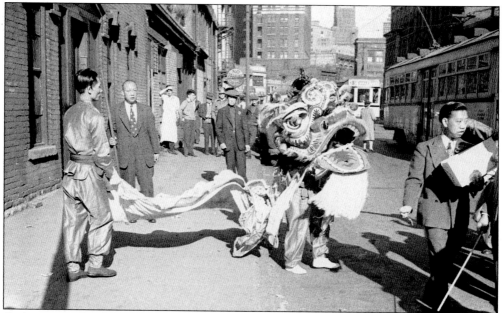

Corktown was bordered on the east by Detroit's Chinatown, located at Michigan Avenue and Third Street. The small Chinese community remained at that location until the early 1950s, when the neighborhood was demolished in order to construct the John C. Lodge Freeway. This group was celebrating an ethnic holiday in 1940 by doing the dragon dance. (Courtesy of the Walter P. Reuther Library, Wayne State University.)

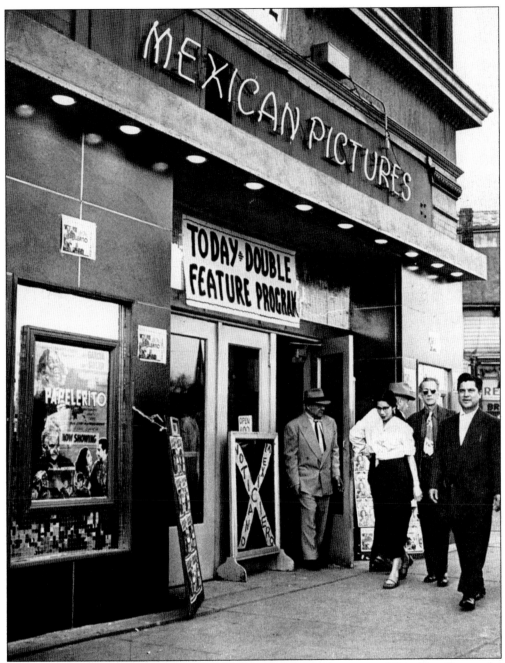

Formerly the Brooklyn Theatre on the corner of Michigan Avenue and Brooklyn Street, the Azteca Theatre served the Spanish-speaking population of Detroit until the 1950s with movies from Spain and Latin America. Like so many movie theaters all over America, competition from television and movement out of the neighborhood led to the closing of the Azteca. (Courtesy of the Burton Historical Collection, Detroit Public Library.)

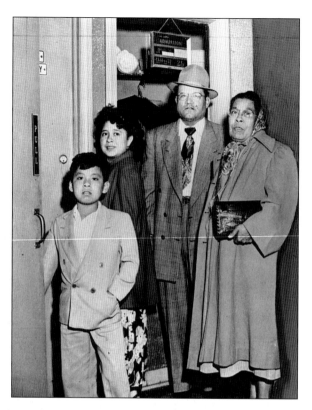

This Mexican American family is about to enjoy an evening at the movies. The Azteca Theatre on Michigan Avenue and Brooklyn Street was a neighborhood gathering spot for many years. (Courtesy of the Burton Historical Collection, Detroit Public Library.)

The growing number of Mexican and Latin American residents of Detroit who were centered in Corktown established their local newspaper, *Union*, and published it in Corktown. Shown here is an advertisement from an issue from 1950. Although the Spanish-speaking population of Detroit has grown, the paper is no longer published.

TEATRO

Åzteca

Michigan Avenue y Brooklyn
Tel. WOodward 2-4630
El Unico en la Ciudad en Español

VIERNES, SABADO, DOMINGO Y LUNES

Dic. 15, 16, 17 y 18
La Familia Pérez
Sara García y Joaquín Pardavé

Dic. 22, 23, 24 y 25
Eugenia de Montejo
Amparito Rivelles y Fernando Rey

Dic. 29, 30, 31 y 1ro de Enero 1951
Puerta Jóven
Con Cantinflas y Silvia Pinal

Enero 5, 6, 7 y 8
Yo Quiero Ser Mala
Con María Elena Marquez, Abel
Salazar, Pedro Vargas y el
Trío Los Panchos.

Horas: Viernes y Lunes 5:30--9:30
Sábados y Domingos 1:30—9:30

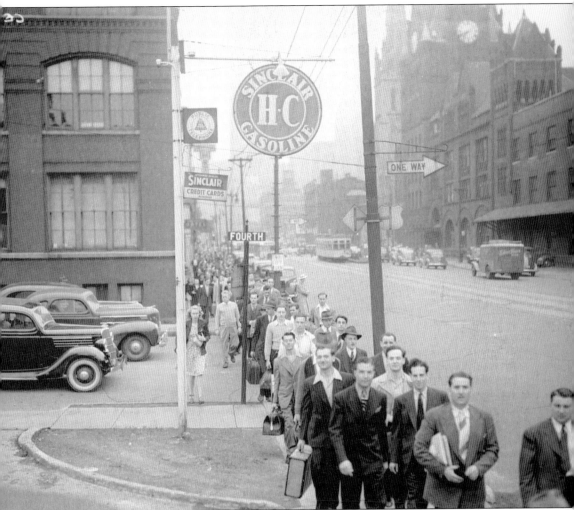

Many of Detroit's selective service offices were on Fort Street in Corktown until the 1980s. During peace and wartime, young men registered for the draft there and, in this case, set out from the center for basic training during World War II. They only needed to traverse Corktown to get to Fort Wayne, located to the west down Jefferson Avenue. (Courtesy of the Walter P. Reuther Library, Wayne State University.)

This building, which had a retail space on the ground floor and a residential apartment above it, was typical of the commercial buildings in Corktown for most of its history. The building shown was on Bagley Street and is reputed to have been owned by Henry Ford before his automobile venture paid off. (Courtesy of the Walter P. Reuther Library, Wayne State University.)

To many Detroiters, Corktown was an old, worn-out neighborhood, but most of the buildings were in decent shape. This picture from the 1930s shows houses that could be found in the 21st century. Only the presence of the old automobile dates the photograph. (Courtesy of the Walter P. Reuther Library, Wayne State University.)

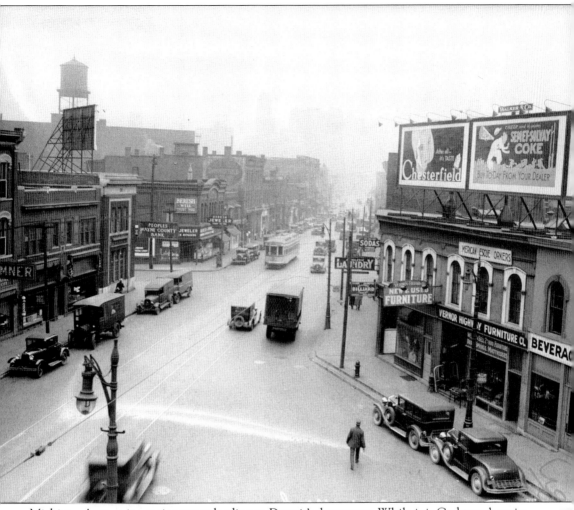

Michigan Avenue is a major artery leading to Detroit's downtown. While it is Corktown's main commercial street, it also serves the entire west side of the city. This picture was taken in the 1920s from the corner of Eighth Street on the east side of the police station. Notice how narrow the avenue is. It was widened soon after the photograph was taken. (Courtesy of the Walter P. Reuther Library, Wayne State University.)

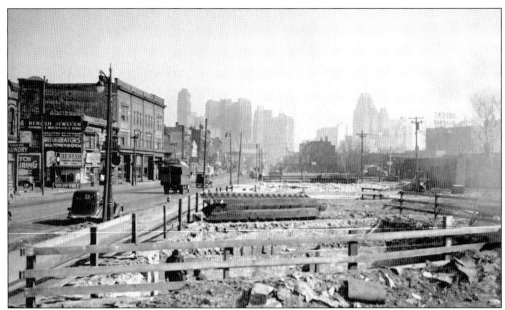

These photographs were taken of Michigan Avenue at Eighth Street in the 1930s when Michigan Avenue was being widened to accommodate the growing number of cars on Detroit's streets. This accounts for the fact that the buildings on the south side of Michigan are mostly newer than those on the north side. It marks the first part of the destruction of much of Corktown in the name of progress. (Courtesy of the Walter P. Reuther Library, Wayne State University.)

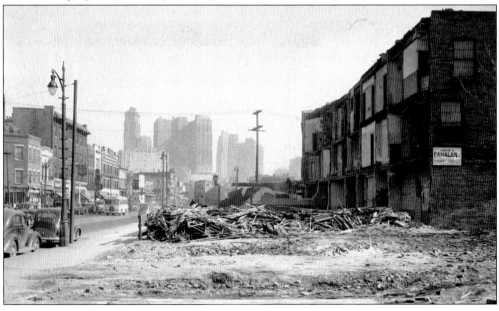

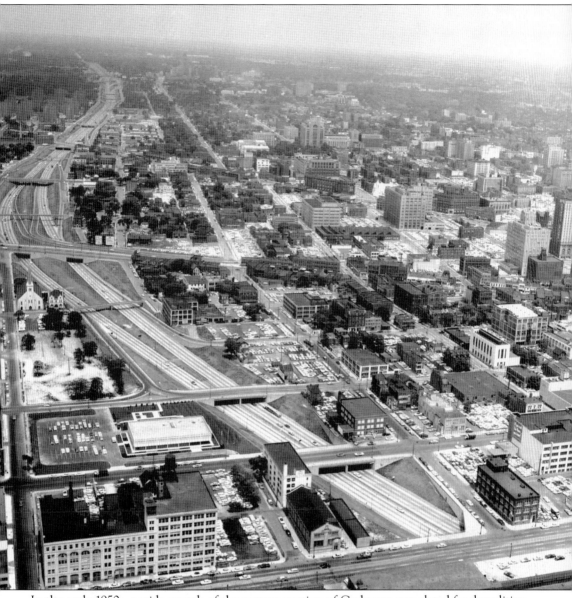

In the early 1950s, a wide swatch of the eastern portion of Corktown was slated for demolition to build the John C. Lodge Freeway from downtown to the northwest part of Detroit. The new superhighway was to be the pride of Detroit, but for Corktown, it was the beginning of the city's chipping away of the neighborhood. Many homes, businesses, and churches, including St. Paul's Maltese Church, were destroyed in the name of progress. (Courtesy of the Walter P. Reuther Library, Wayne State University.)

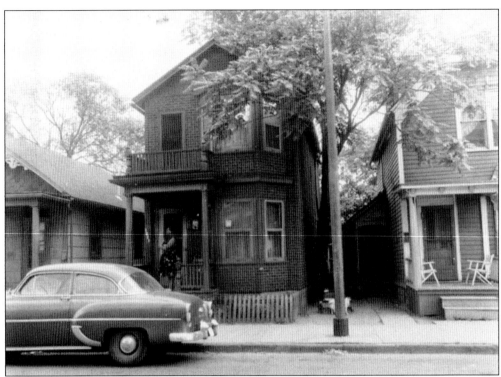

The destruction of much of Corktown by the city in the 1950s was a catastrophe for most of the neighborhood. These two photographs show homes on Abbott Street (above) and Howard Street prior to the demolition. Highway construction and urban renewal eliminated a considerable part of the community before the residents organized to bring it to a halt. (Courtesy of Rosalinda Ybarra.)

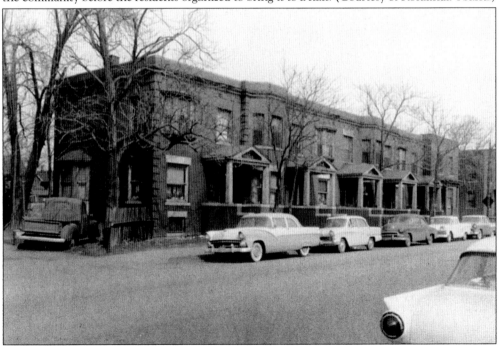

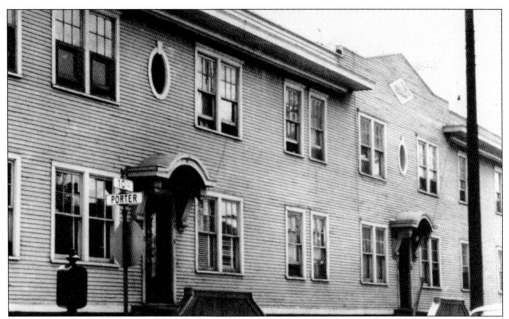

This row house at the corner of Porter and Tenth Streets was torn down in the early 1950s. The City of Detroit was determined to raze the Corktown neighborhood and rezone the area for light industry that, it was hoped, would encourage the growth of industry within the city limits. While some new industries were encouraged to locate there, the results were not what the planners had hoped. (Courtesy of Michael Clear.)

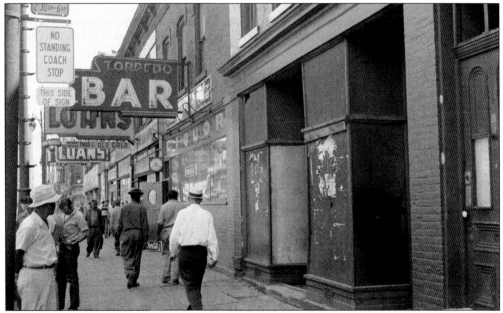

Separating Corktown from downtown was a few run-down blocks referred to as "skid row." This collection of bars and pawn shops was a source of resentment among the residents of the community who feared the bad example for their children. Skid row was demolished in order to build the Lodge freeway in 1950, the only positive result for the neighborhood from the highway's construction. (Courtesy of the Walter P. Reuther Library, Wayne State University.)

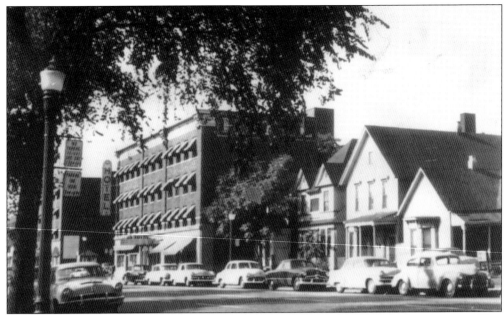

The Roosevelt Hotel on Fourteenth Street borders the Michigan Central Railroad station. This picture from 1950 shows the hotel when it served travelers arriving in the city by train. The western part of Corktown was intimately related to the station with commercial establishments, hotels, and shops. After several years of abandonment, the hotel awaits renovation into condominiums. (Courtesy of Michael Clear.)

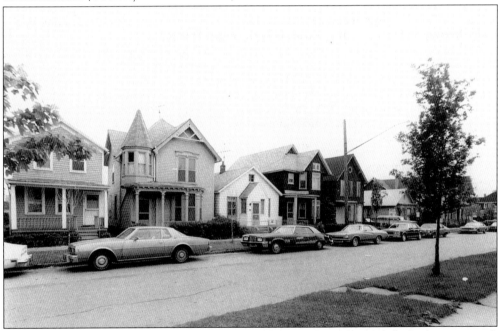

Here is one of the Corktown streets lost to progress during the 1950s. While the housing stock was old and, in a few cases, weathered, most of it was still well maintained and only suffered from being out of date. However, the community was able to rally and save some of the neighborhood from the changes. (Courtesy of Michael Clear.)

Three

RECENT HISTORY

The end of World War II ushered in a period of great change for Corktown. Renewal and redevelopment were popular themes among city planners of the 1940s through the 1960s. The city planners considered Corktown's residential nature an obstacle to the city's growth. Proponents of urban renewal sought to turn the area into a light industrial zone in order to retain industry in the near-downtown area.

Changes in transportation during this era led to the building of expressways that facilitated automobile traffic into and out of the downtown area. In order to accomplish this, large tracts of housing and businesses were destroyed in order to build the Lodge freeway in the early 1950s as well as the Fisher Freeway a decade later. Corktown was cut off from downtown Detroit by the Lodge freeway and was split into two areas by the Fisher Freeway.

Further west on Michigan Avenue, the Michigan Central Railroad station was feeling the effects of the rapid drop in rail traffic due to improved highway travel and the rise of air travel while the Union Station on the east end of Corktown was demolished.

Reflecting its sole tenants, Briggs Stadium became Tiger Stadium when it lost the Detroit Lions to the Pontiac Silverdome. In 2000, the Tigers abandoned the old stadium for their new home, Comerica Park, in the emerging entertainment district of downtown Detroit. The prognosis for the neighborhood was bleak.

However, Corktown residents and their supporters were not going to let their neighborhood die. The residents fought the demolition of their community and contained the destruction, leaving the core area south of Michigan Avenue intact. Gaining historical designation in the 1970s, a reinvigorated community became a beacon for the rest of the city, showing what active citizens could accomplish.

No longer an ethnic enclave, Corktown nevertheless has managed to attract new residents and businesses despite the loss of the train station and the Detroit Tigers. Some of the pubs have managed to survive and prosper while new restaurants and saloons have moved into the neighborhood, giving it new life. The new Worker's Rowhouse Museum, the Greater Corktown Development Organization, the Gaelic League, the Maltese Benevolent Association, the Most Holy Trinity Church and other churches, the bars and restaurants, and other groups have continued to give the neighborhood its flavor.

Corktown is an exceptional example of how grassroots activism by regular people can have an impact on their environment. Its success at survival and managing change is an inspiration to all who live there, work there, are entertained there, and worship there. The future of the community looks very bright.

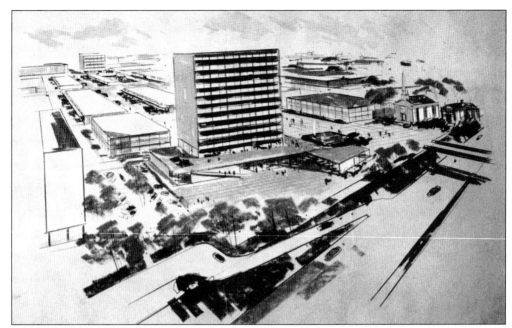

In the 1950s, the prevailing opinion regarding urban renewal meant demolition of the old and creation of a new environment. The City of Detroit proudly proclaimed that Corktown would be replaced with a modern industrial park that would look like this. Today many of the buildings that were to save Corktown are abandoned while the remnant of the old neighborhood is resurging. (Courtesy of the Walter P. Reuther Library, Wayne State University.)

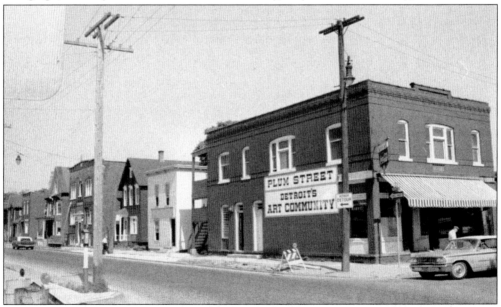

Plum Street, on the eastern edge of Corktown, became a center for artists and countercultural groups during the 1960s. For a short time, it became a lively center for young people from throughout the metropolitan Detroit area in which to shop and hang out. However, it fell upon hard times due to criminal activities and failed businesses. It was demolished in the late 1960s in order to build the Jeffries Freeway. (Courtesy of the Walter P. Reuther Library, Wayne State University.)

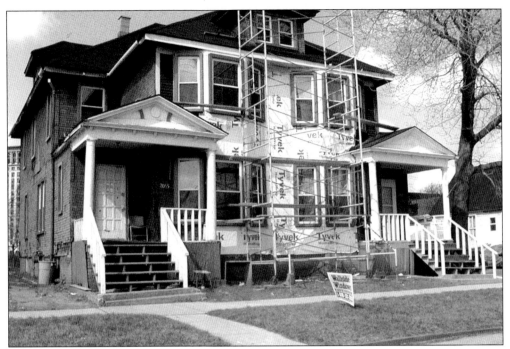

A welcome sight on the streets of Corktown is that of restoration and renovation. The side-by-side duplex on Vermont Street is undergoing a face-lift on the outside and an updating on the inside.

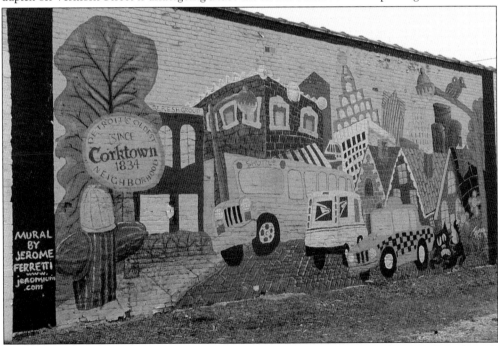

Public art is an important part of making a neighborhood interesting. This mural on the side of a building on Michigan Avenue west of the Lodge freeway was commissioned by the Greater Corktown Development Corporation in the early 21st century and is admired by hundreds of people every day. The artist is Jerome Feritti.

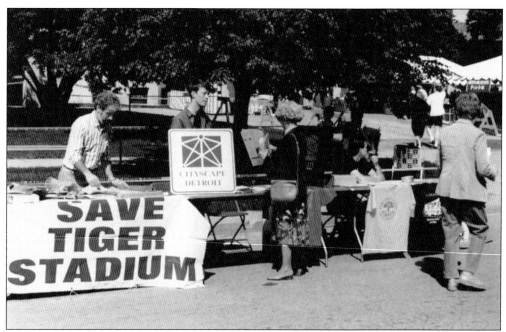

During the 1990s, many people in Corktown worked to convince the community that Tiger Stadium should remain the home of the Detroit Tiger baseball club. This table at the Detroit Festival of the Arts hoped to convince passersby that they should support their cause. While their cause failed, Corktown managed to overcome the loss of the baseball team.

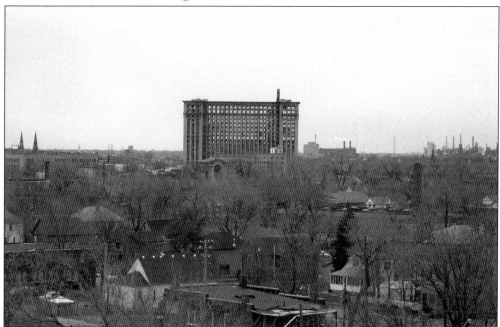

The Michigan Central Railroad station, which was the portal to Detroit for so many immigrants and visitors throughout the 20th century, has been abandoned and is in danger of demolition. Despite the attempts by preservation groups to preserve the building for adaptive reuse, little hope remains for its future. (Courtesy of the Walter P. Reuther Library, Wayne State University.)

Residents of Corktown have had a number of publications serving to keep the lines of communication open with residents. The *Corktown Crier*, while no longer in publication, has been one of a series of ways for promoting neighborhood solidarity.

This pamphlet has been produced in order to promote the neighborhood as a great place to live and visit. The Greater Corktown Development Corporation has promoted the community to the greater Detroit area. Note the logo on the pamphlet, which is found throughout the neighborhood as an emblem. (Courtesy of the Greater Corktown Development Corporation.)

Corktown

A Detroit Historic District

The Corktown Citizens District Council has taken an active role in promoting the neighborhood as a great place to live, work, and visit. This postcard is an example of their campaign to make the Greater Detroit region aware of this exciting community.

GREATER

CORK TOWN

ECONOMIC DEVELOPMENT CORPORATION

1459 BAGLEY STREET
Detroit, Michigan
48216 - 1910

(313) 962-5660
Fax:
(313) 962-7170

The mission of the Greater Corktown Development Corporation is to support growth and development of the greater Corktown area for the purpose of purchasing or investing in property, assets, joint ventures, and limited partnerships with individuals, communities, private organizations, and government agencies.

Four

CHURCHES AND EDUCATION

The bedrock that builds a feeling of community in towns and neighborhoods consists of institutions that offer the inhabitants a sense of continuity with their past, a sense of purpose for the present, and a hope for the future. In Corktown, the churches and schools have existed for generations and supported their people by fulfilling these needs. Many of the churches in Corktown have existed for over a century and continue into the 21st century to offer their members the spiritual and practical inspiration that reflects the needs of the community. In addition to fulfilling the spiritual needs of their members, the churches established by Irish immigrants also provided schools to educate their children in their religion as well as prepare them to make a living and become contributing citizens of their city and society. While some of the schools have become victims of changing demographics that resulted, in part, from their own success, others remain to inspire young people in the 21st century just as their predecessors did in the past.

The Detroit Public Schools has long provided Corktown's residents with educational opportunities. While times have changed and many schools have come and gone, several continue to serve the community including the Webster School and the Benjamin Franklin School. Franklin School has changed its name to the Burton International School and still serves young people who are new to the United States as well as the residents of the surrounding neighborhood. The Houghton School that served the core of Corktown for many years was demolished during the 1950s. The parochial high school at St. Vincent's parish served students from the other parishes as did several neighboring schools such as St. Leo's, Girl's Catholic Central, and the University of Detroit Jesuit High School. Public high schools in the area include Cass Technical High School, which has always drawn students from the entire city, and Western International High School, which includes students from southwest Detroit. Many of these fine public and private schools continue to educate the children of Corktown into the present century.

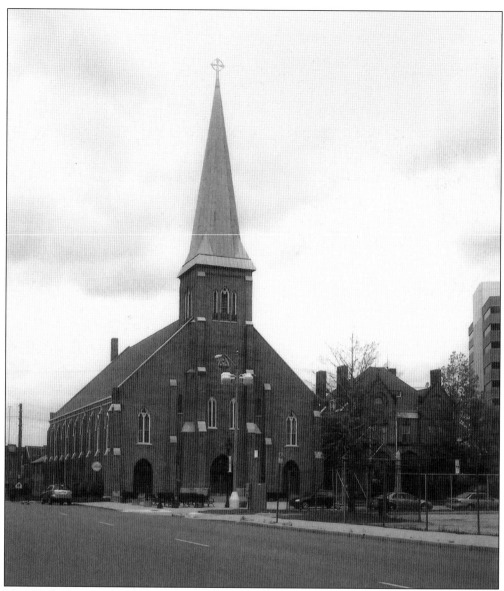

Most Holy Trinity Church was the second Catholic parish organized in Detroit. It was the first English-language parish that was organized to serve the rapidly increasing Irish population of the city in the 1830s. The original building was moved on rollers to Corktown from downtown in 1849 to anchor the Irish community that was settling there. The current building was built around the old edifice and consecrated in 1866. The Gothic Revival church has served the Corktown community for over 150 years and has served many nationalities while remaining a sentimental favorite to Irish Detroiters for its entire existence.

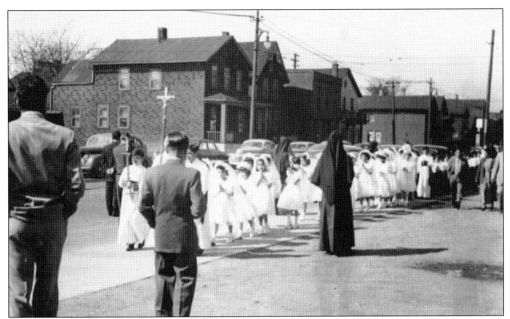

This procession of girls, dressed like little brides, is walking into Most Holy Trinity Church to receive their first communions. Rites of passage have been important to the lives of Corktowners throughout the years and are usually shared with friends and neighbors. Public processions by religious communities were a common sight in Corktown throughout its history. (Courtesy of Rosalinda Ybarra.)

The Immaculate Heart of Mary nuns staffed both Most Holy Trinity and St. Vincent schools for many years. Their dedication to the education and spiritual well-being of the children of Corktown has left an imprint on thousands of people who have benefited from their hard work. Here a sister accompanies the First Holy Communion class from Most Holy Trinity Church in the 1950s. (Courtesy of Rosalinda Ybarra.)

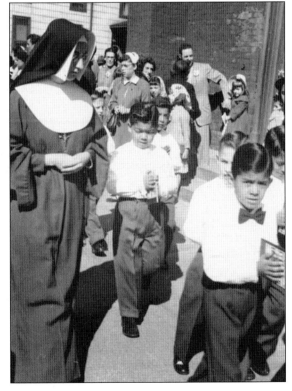

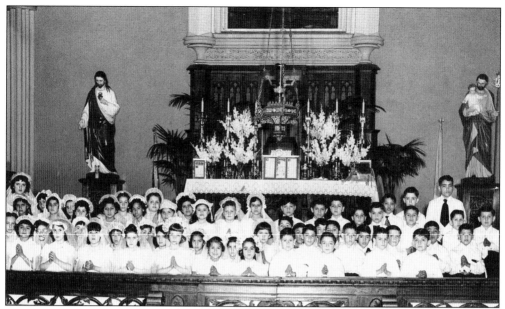

By the 1940s, Corktown had become home to people of diverse ethnic backgrounds. These children making their First Holy Communion are standing in front of the main altar at Most Holy Trinity Church. They represent the many cultures residing in the parish. (Courtesy of Michael Clear.)

Although residents of Irish descent are no longer predominate in Corktown, the neighborhood and Most Holy Trinity Church continue to hold a place of esteem in the Irish community of Detroit. Pictured here is the Reverend John Devine, formerly of Most Holy Trinity Church, who began the tradition of the "sharin' of the green" at Trinity. Each year on St. Patrick's Day, a mass is said in the church, attended by thousands of Detroiters, which collects money for charitable works sponsored by the church. (Courtesy of Peggy Walsh.)

The current pastor of Most Holy Trinity Church, Fr. Russ Kohler, on the right, is shown here with Bishop John Quinn preparing to process into the church to celebrate the annual St. Patrick's Day mass in 2005. Kohler continues the long tradition at Most Holy Trinity of serving the poor and the helpless not only in the parish but also throughout the metropolitan area. (Courtesy of the Most Holy Trinity Church.)

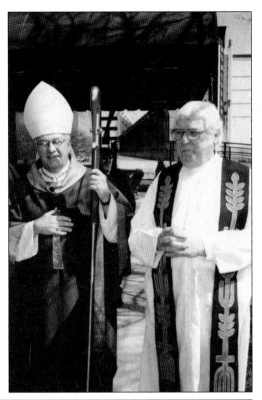

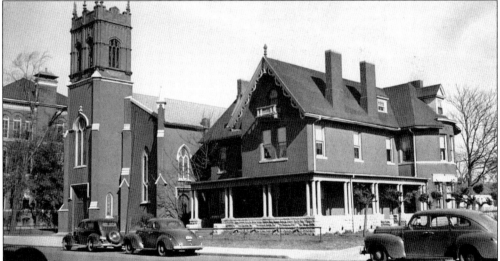

The rapid growth of Corktown in the mid-18th century is attested to by the organization of a new parish on the western end of the neighborhood. St. Vincent de Paul Church was consecrated in 1866 and included both an elementary and a high school. Although the majority of the parishioners were Irish initially, St. Vincent and Most Holy Trinity churches included some French and other non-Irish parishioners. By the 1900s, many members of both parishes were Mexican or Maltese, reflecting the rapid growth of these communities and the movement to other neighborhoods of the Irish families. (Courtesy of the Walter P. Reuther Library, Wayne State University.)

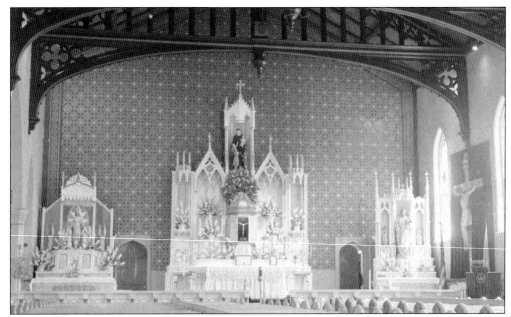

The interior of St. Vincent's church reflected a traditional Catholic church with a main altar, two side altars, and the stations of the cross along the sides. With the decline in population that resulted from the demolition of much of the neighborhood in the 1950s, St. Vincent's church and old school building were demolished. The middle school remained open for a few years, but it too is now closed. (Courtesy of the Walter P. Reuther Library, Wayne State University.)

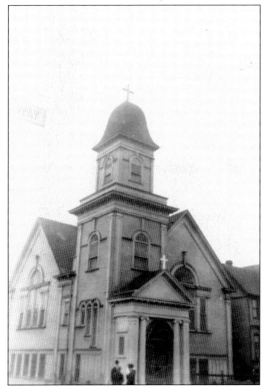

Following World War I, many Maltese immigrated to the United States. The most common destination of Maltese in America was to Detroit, and Corktown was the center of the community. Since the majority of Maltese immigrants were Catholic, they joined the local parishes, but soon organized their own church, St. Paul, with a pastor from Malta, Fr. Michael Borg. This church served the Maltese Catholics until it was demolished in 1952 to make way for the Lodge freeway. (Courtesy of the Archdiocese of Detroit archives.)

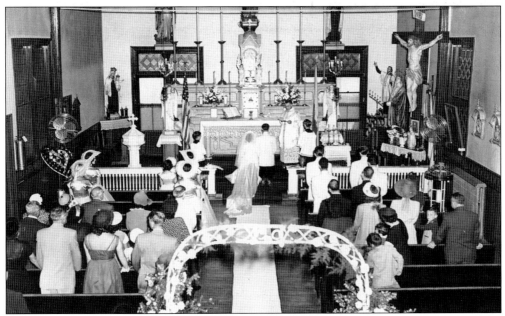

The interior of St. Paul's church was familiar to the Maltese community as the scene of life's milestones, including baptisms, sacramental life, and funerals, as well as the weekly services. Pictured here is the wedding of Mary Tabone and Charles Brincat, which was celebrated in the early 1950s. The church was elaborately decorated for the occasion. (Courtesy of Charles and Mary Brincat.)

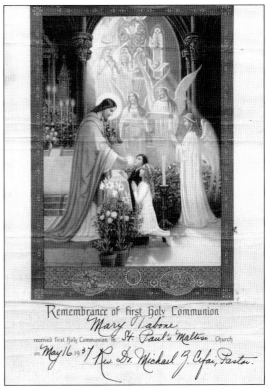

For members of many ethnic groups that settled in Corktown, religious rituals were a cause for celebration. Mary Tabone's souvenir of her First Holy Communion at St. Paul's Maltese Church would resemble those of her Mexican, Irish, German, and other American neighbors. (Courtesy of Charles and Mary Brincat.)

Remembrance of first Holy Communion
Mary Tabone
received first Holy Communion in St. Paul's Maltese Church
on May 16 1937 Rev. Dr. Michael J. Cefai, Pastor.

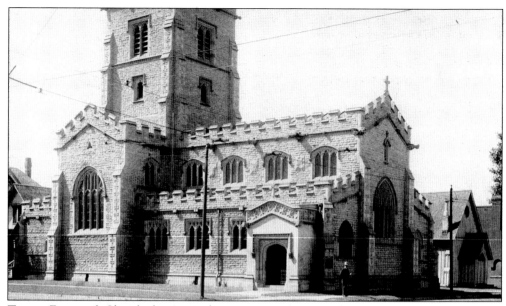

Trinity Episcopal Church, known today as Spirit of Hope Church, continues to serve the communities of Corktown and Woodbridge. It is now a blend of Episcopal and Lutheran traditions. Built in the 1890s to the exacting specifications of its benefactor, *Detroit News* founder William Scripps, it is one of the first Gothic Revival churches built in the city of Detroit. The present growing congregation is committed to respecting and preserving the legacy of this beautiful church while it serves its congregation and the community. (Courtesy of the Spirit of Hope Church.)

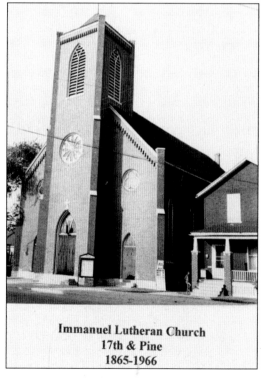

Immanuel Lutheran Church
17th & Pine
1865-1966

A testament to the large German population of Corktown, Immanuel Lutheran Church and School were established in 1865 at Seventeenth and Pine Streets. The congregation grew rapidly and served its members until 1966. This photograph shows the exterior of the church a short time before it was demolished for the construction of the Fisher Freeway. (Courtesy of the Historic Trinity Lutheran Church.)

St. Paul's German Evangelical Church was built in 1873 to serve the growing German population of Corktown. The congregation thrived until the early 20th century when members began to move to distant parts of the city and the suburbs. This Gothic building still stands on Seventeenth Street in the shadow of the Michigan Central Railroad station.

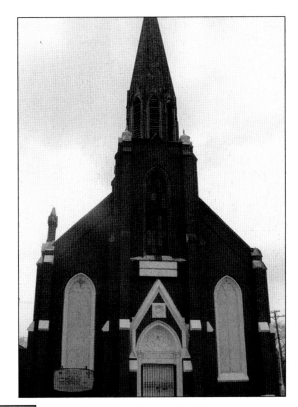

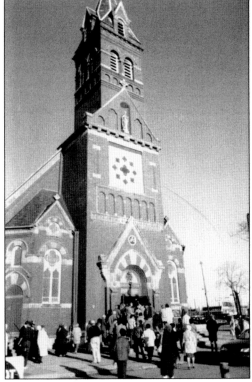

German Catholics that settled in Corktown sought and received permission in 1869 from the Archdiocese of Detroit to establish a church of their own. St. Boniface was located north of Michigan Avenue and due west of the baseball stadium. The church was closed in the 1980s and demolished to make room for parking for Tiger Stadium. (Courtesy of the Archdiocese of Detroit archives.)

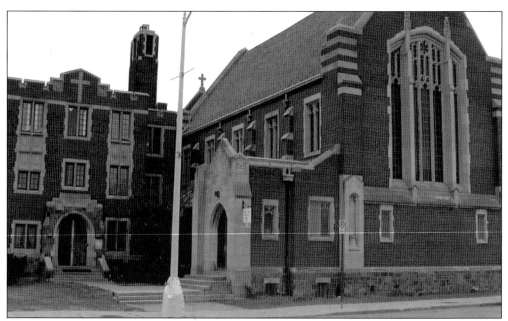

St. Peter's Episcopal Church was founded in 1858 and has undergone changes several times in its long history. Founded by Irish Protestant immigrants, it was the scene of the marriage of Henry Ford's parents in the 1860s. The present building is a product of the mid-20th century, and the small but enthusiastic congregation consists of a diverse group of people who live out their faith by supporting a number of social service activities in the neighborhood.

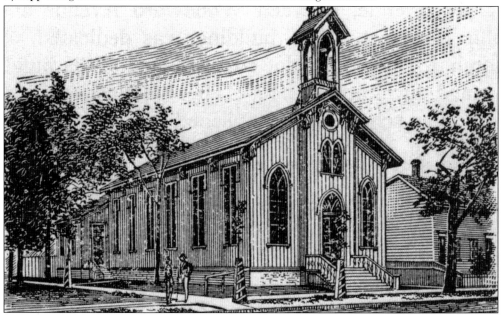

Trumbull Avenue Congregational Church was established in 1868 and was moved in 1887 to the corner of Baker Street, now Bagley Street, and Trumbull Avenue. The church was demolished in the 1950s. The parking lot for the Baile Corcaigh restaurant now occupies that location. The members of the church were predominantly of Scottish and Welsh descent, most of whom settled in Detroit from the New England states.

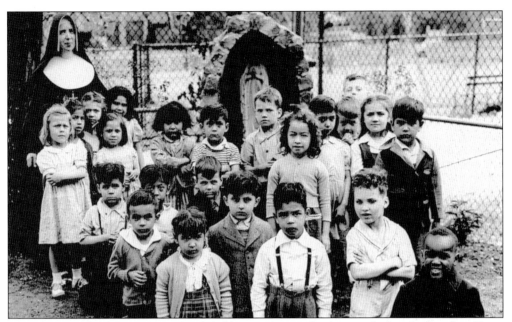

This photograph of elementary school children in the parish grotto with their Immaculate Heart of Mary nun at Most Holy Trinity School in the 1940s shows the diversity that has characterized Corktown throughout the 20th century. The Immaculate Heart of Mary sisters had been a predominantly Irish order in their early history but soon began to reflect the diversity of their students. (Courtesy of the Archdiocese of Detroit archives.)

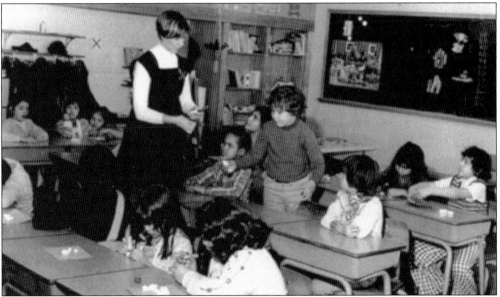

Many changes have occurred at Most Holy Trinity's school over the years. Students are no longer taught exclusively by nuns, and the nuns that remain no longer wear the traditional black and blue habit. The old Victorian building on Porter Street has been demolished, but a modern building was constructed in the 1960s to replace it. What remains is the commitment to excellence that has prevailed for over one and a half centuries. (Courtesy of the Archdiocese of Detroit archives.)

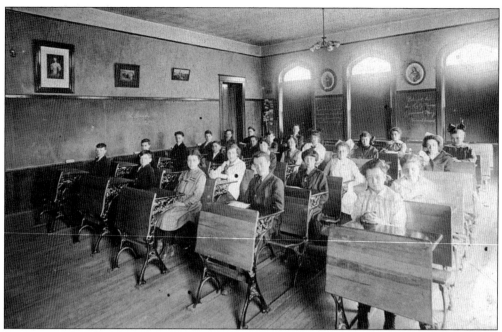

St. Anne's Church and School borders Corktown on the west. Although founded by the early French settlers of Detroit in 1701, it has been the spiritual and educational home to many people throughout its history. Students from Corktown were included in this classroom in the 1880s. (Courtesy of the Archdiocese of Detroit archives.)

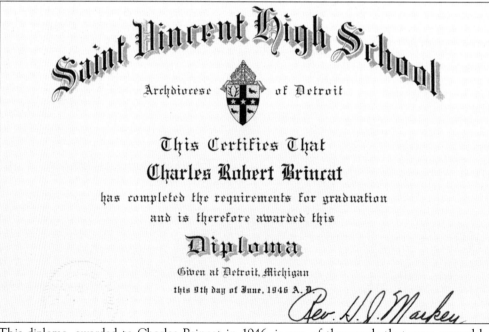

This diploma, awarded to Charles Brincat in 1946, is one of thousands that were earned by residents of Corktown over its long existence. Brincat attended St. Vincent's High School, as did many students who belonged to St. Paul's Maltese parish or Most Holy Trinity parish. (Courtesy of Charles and Mary Brincat)

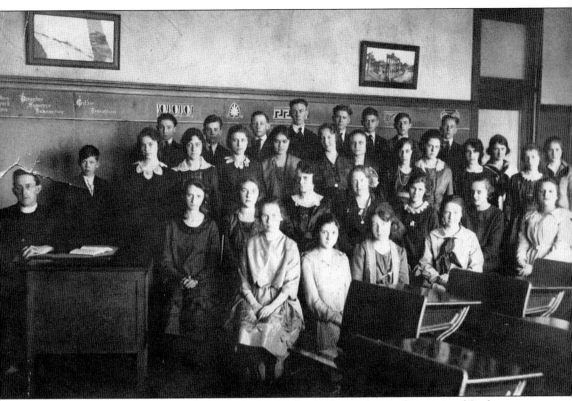

These students were a high school class at St. Leo's school serving the northern area of Corktown and other neighborhoods beyond. As the Irish population of Corktown expanded, many people moved north and west but continued to think of Corktown as their home.

Still in use, though now called the Burton International Elementary School, the Benjamin Franklin School was originally built in 1865 and replaced in the early 20th century with this building. Although fewer elementary students live in the neighborhood, the Detroit Board of Education deemed Corktown to be the logical home for the staff and students of this magnet school. (Courtesy of the Walter P. Reuther Library, Wayne State University.)

Several Detroit public schools have served students in Corktown over the years. The Houghton Elementary School was one of the first when it opened in 1853. Originally called the Eighth Ward School, it was renamed in honor of Douglas Houghton, the first president of the board of education. This building was demolished in the 1950s when this park of Corktown became an industrial park. (Courtesy of Mary Luna Abbott.)

The intense loyalty of Corktown residents to their traditions and heritage is attested to by the pride of Houghton Elementary School's graduates for their school. Each year, alumni gather to reminisce and to maintain the ties that were formed in their elementary school years. (Courtesy of Mary Luna Abbott.)

Douglas Houghton School Reunion 16th Anniversary

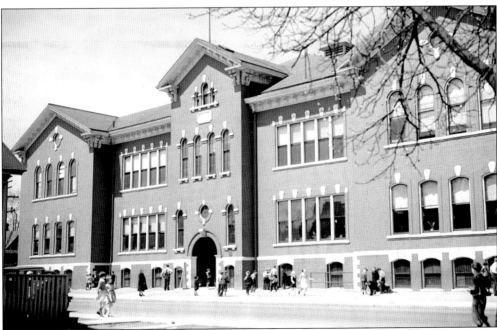

The Owen Elementary School was built in 1879 to serve the northern part of Corktown. It sat at the corner of Thirteenth Street and Myrtle Street. The building shown here included the original building and two additions flanking the old center. It has been demolished. (Courtesy of the Walter P. Reuther Library, Wayne State University.)

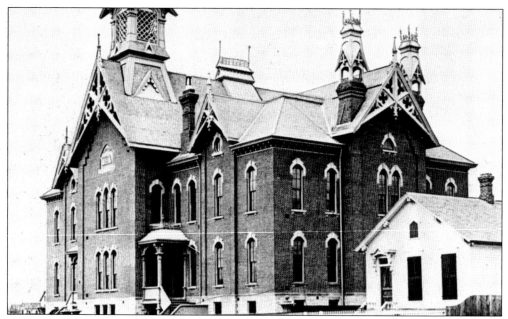

When Webster School was erected in 1874 on the western edge of Corktown, it created controversy over its elaborate gingerbread architecture and its cost. The result was that future schools would be constructed with a simpler design. It served as a temporary high school after Detroit's first public high school burned in 1893 and until Western High School could be constructed. (Courtesy of the Walter P. Reuther Library, Wayne State University.)

Detroit Public Schools located its high school in the old state capital building downtown until it burned down and a new high school was constructed in the upper-middle-class neighborhood at Cass and Warren Avenues in 1890. This grand structure, called Central High School, attracted scholars from throughout the city, including Corktown. It changed its mission when the Detroit Public Schools decided to open a college. It is now known as Old Main, the heart of Wayne State University.

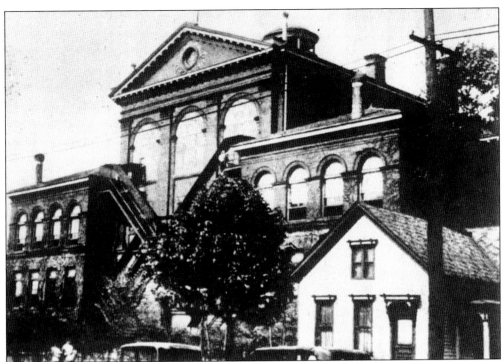

Western High School was constructed in 1895 in order to accommodate the growing population in Corktown and the neighborhoods to the west and north. This imposing building (above) served until a tragic fire in the 1930s resulted in its destruction. Below is the building that replaced it. It continues to serve the Corktown community as well as Mexicantown with many students attending from other parts of Detroit. (Courtesy of the Walter P. Reuther Library, Wayne State University.)

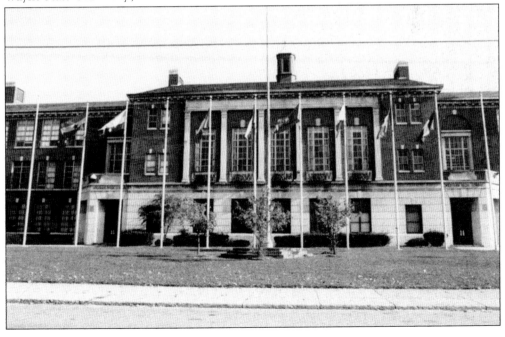

Cass Technical High School is to the east of the Corktown community and has attracted many students throughout its history. The school was named for one of the original owners of the farmland that was to become Corktown, Lewis Cass. From its inception, the school has been nationally acclaimed for its rigorous technical and academic programs.

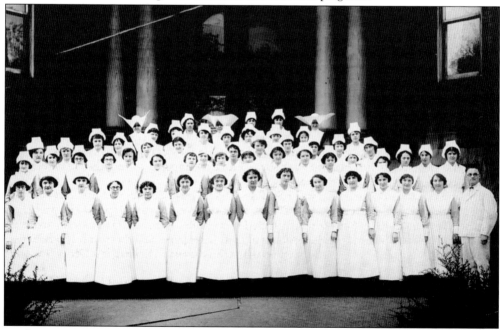

As the immigrant communities that lived in Corktown prospered, many of their children went on to higher education. In the early 1900s, education and nursing were the two acceptable careers for women. Many young Corktown women attended the Providence Hospital School of Nursing nearby on West Grand Boulevard.

Five

PUBLIC AND PRIVATE INSTITUTIONS

Over the years, a number of public institutions and landmarks have defined the neighborhood. The proximity to downtown made the neighborhood the logical end of the line for major railroads coming from the south and west into the city. The Michigan Central station has been an icon on the western approach to Corktown for almost a century. The rail line for the Union Central Railroad also crossed Corktown as it led to the terminal on Fort Street at First Street. These transportation hubs at either end of Corktown contributed to the neighborhood's connection to the rest of the city, state, and nation for the first century of its existence.

In 1898, William Bennett turned the corner of his farm at the intersection of Michigan and Trumbull Avenues into a ballpark. Over the years, the park has evolved into Navin Field, Briggs Stadium, and finally Tiger Stadium. By 2003, a new state-of-the-art baseball stadium became the home of the Detroit Tigers, and the site of the old stadium in Corktown has waited for its fate to be determined.

While not noted for an architectural presence, the Gaelic League has anchored the neighborhood for many decades and has helped to maintain ties to the Irish immigrants that formed the community. Its home on Michigan Avenue has brought thousands of Irishmen and others to celebrate the best of Irish camaraderie in the heart of Corktown. It has served since 1958 as the terminus for the ever-popular St. Patrick's Day parade down Michigan Avenue. The parade, sponsored by the United Irish Societies, takes place every year on the Sunday preceding March 17. It includes floats from dozens of societies, churches, fraternal organizations, and even saloons. Every year, thousands of descendants of Irish immigrants and thousands of others who are Irish for the day celebrate the saint that brought Christianity to Ireland. It is Detroit's version of Marti Gras.

In addition to its Irish institutions, Corktown is also home to groups that honor other ethnic heritages. The Maltese Benevolent Society on Michigan Avenue, as well as other groups, celebrate their own history and culture in their old neighborhood.

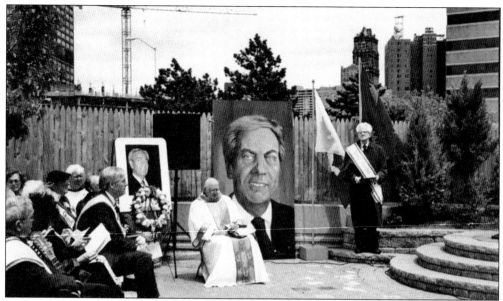

On May 21, 2006, the United Irish Societies dedicated the Irish Plaza, shown above, to past and present members of the Irish community. It is located on Sixth Street south of Michigan Avenue. The plaza was organized under the leadership of Mike McGunn and the late Ed Neubacher of the United Irish Societies. Members of the Irish community of Michigan supported the project by buying bricks to commemorate friends and family. Michael Kerwin is seen presiding while Ed Neubacher's picture is behind Msgr. James Moloney.

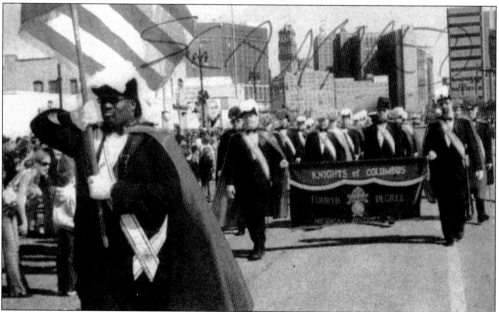

The St. Patrick's Day parade has been held the Sunday before St. Patrick's Day on Michigan Avenue for many years. Previously held on Woodward Avenue, a move to Corktown seemed logical to honor its roots and to be near the Gaelic League. Pictured here is the 2007 parade. The festive parade and celebration lasted into the night at the various clubs and saloons of Corktown. (Courtesy of the Michigan Catholic.)

The St. Patrick's Day parade attracts thousands of visitors to Corktown each year. The enthusiastic crowds await the floats and scramble to catch the candy and trinkets thrown by the participants.

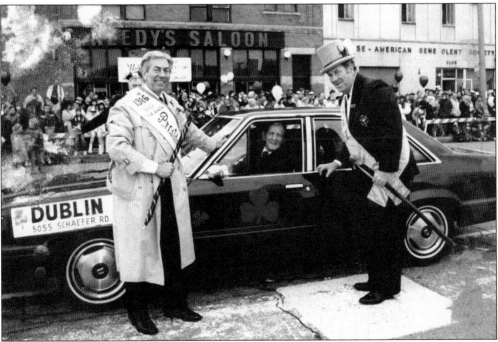

The parade has always attracted many prominent Detroiters. Pictured at the 1986 parade, from left to right, are Ed Neubacher, president of the Fraternal Order of United Irishmen; Mike Griffin, in his car, the owner of the Dublin Inn; and "Black Jack" Kelley, a member of the Detroit City Council.

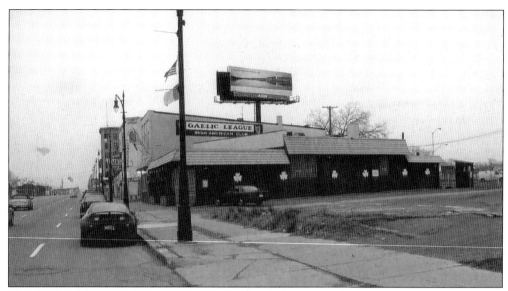

The Gaelic League and Irish-American Club was formed in 1920 to preserve and promote Irish culture in Detroit and to support the Irish republic. At the time of its inception, Ireland was struggling to become free of English rule and Irish Americans organized to support their ancestral homeland's quest for freedom. The Gaelic League has been at this site since the 1950s and has been an anchor of Irish presence in Corktown for its long existence. This organization has contributed greatly to the continuing pride and awareness of the Irish ancestry of the many thousands of Michiganites.

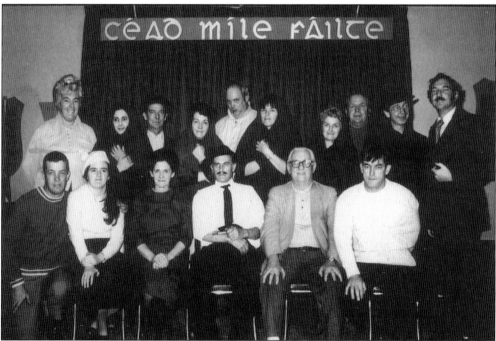

The Gaelic League has been an anchor of Irish culture in Corktown for many years. The Gael Players pictured here consisted of Irish American Detroiters as well as citizens of Ireland who edified and entertained Detroiters at the clubhouse.

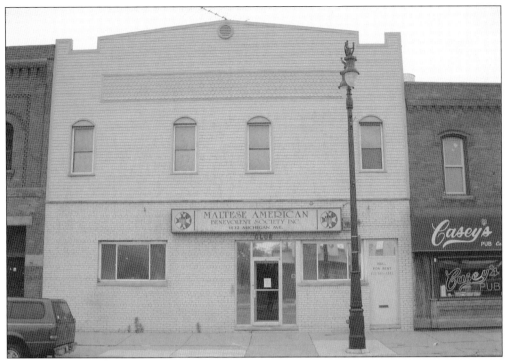

Although the Maltese Catholic church has been demolished, the community still maintains a cultural presence in the neighborhood with the Maltese American Benevolent Society on Michigan Avenue. It is the center of meetings, cultural activities, and banquets for the community that has spread throughout the metropolitan area.

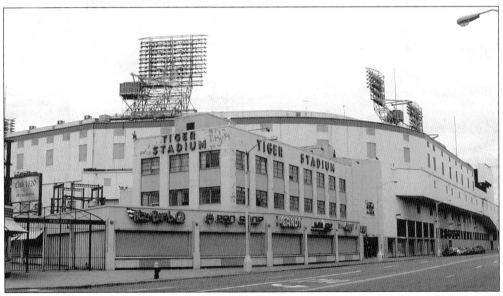

The most famous corner in Detroit has been that of Michigan and Trumbull Avenues. Since 1896, the former hay market has been the site of professional baseball and, for a time, football. Originally called Bennett Park, it became Navin Field in 1912, Briggs Stadium in 1938, and finally Tiger Stadium in 1961. For generations of Detroiters, Corktown and the stadium were synonymous.

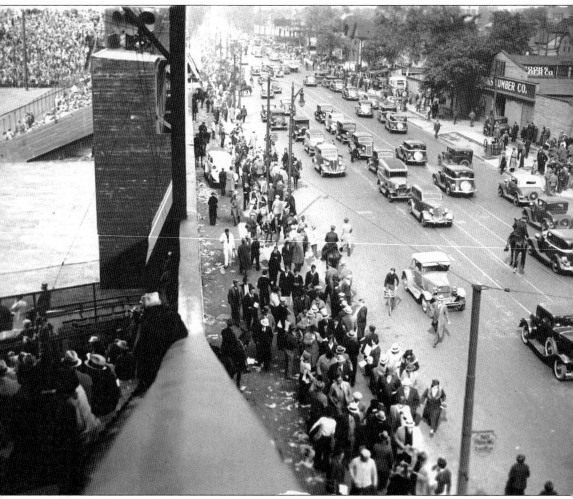

In 1935, the Detroit Tigers won the Major League Baseball World Series. This photograph was taken from Navin Field, soon to be renamed Briggs Stadium. The view shows the excited crowds inside the stadium as well as those outside impeding the traffic on Trumbull Avenue. The anticipation of a win was to come true. (Courtesy of the Bentley Library, University of Michigan.)

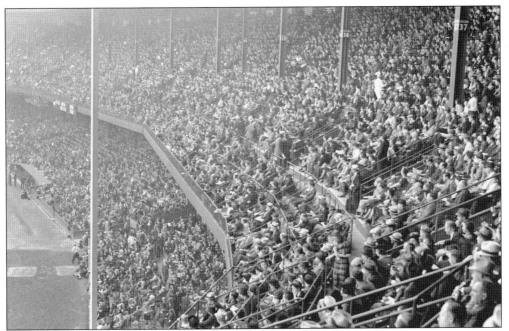

Navin Field was often the scene of huge crowds supporting the home teams; the Tigers for baseball and the Lions for football. While the stadium drew visitors from throughout the region, Corktowners felt a special attachment to their neighborhood sports stadium. (Courtesy of the Walter P. Reuther Library, Wayne State University.)

The Sisters of the Good Shepherd is a Catholic order of nuns dedicated to working with girls that have experienced problems with their families or the law. For over a century, they have maintained a facility for girls in trouble. The building above was located on Fort Street for many years until a new facility was constructed in the suburbs called Vista Maria. This complex was then demolished. (Courtesy of the Walter P. Reuther Library, Wayne State University.)

Most Holy Trinity Church sponsors a legal aid service and the Cabrini Clinic, the oldest free medical clinic in the United States. The legal aid consists of a group of professional volunteers (above) that donate their time so that those less fortunate have access to attorneys when the need arises. The Cabrini Clinic provides medical service to those who cannot afford medical fees. These volunteers (below) are dedicated to helping the poor and less fortunate in the area.

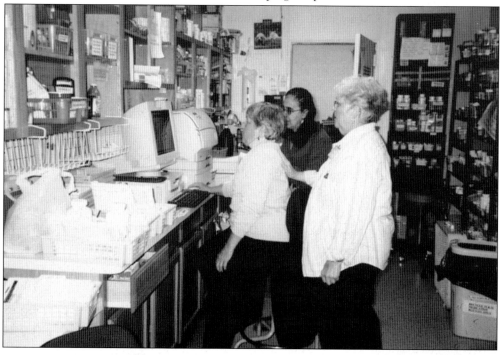

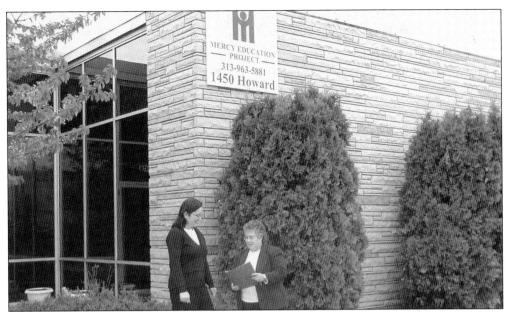

The Mercy Education Project (MEP) was formed in 1992 by the Religious Sisters of Mercy at the former St. Vincent Middle School to provide remedial tutoring for up to 90 girls from grades one through eight. The summer Rise N Shine program provides academics and enrichment. For women, the MEP also offers literacy, adult basic General Education Development (GED) preparation, and career development. In the above photograph, executive director Amy Amador (left) and director of development and marketing Sr. Maureen Mulcrone are standing in front of the new facility on Howard Street. In the picture below, Sr. Jeanette Beudreau tutors young girls at the MEP after school. Many girls from throughout southwest Detroit profit from the programs offered by the MEP.

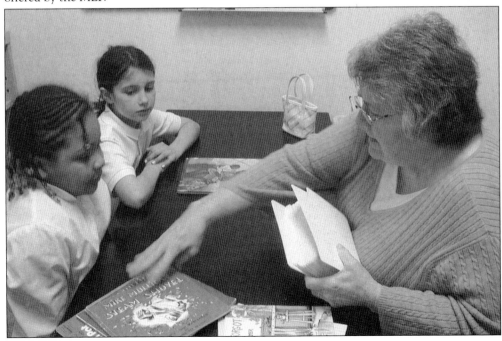

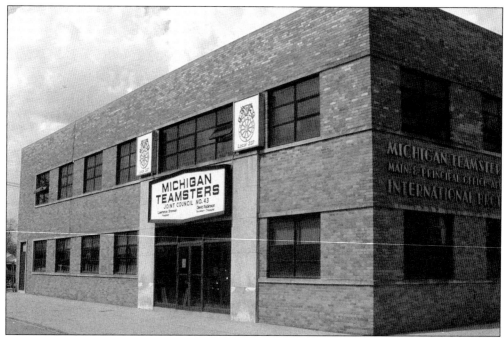

The Teamsters Union has had several locals headquartered on Trumbull Avenue since the 1940s. Included in their cluster are the credit union and the insurance office. These buildings have served thousands of workers in the metropolitan Detroit area.

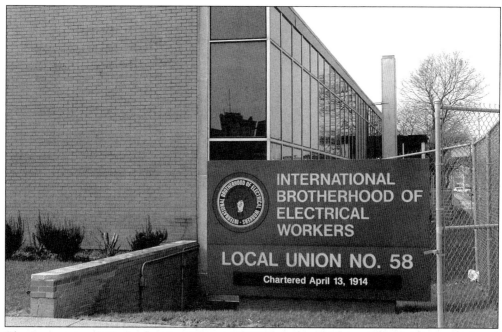

The International Brotherhood of Electrical Workers Local Union No. 58 is one of several unions that are headquartered in the Corktown area. This modern union building was constructed in the 1960s in the Corktown redevelopment area from which the union continues to serve its members.

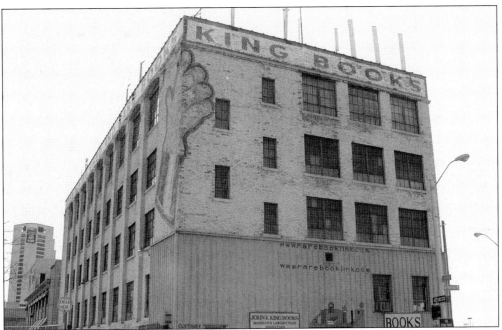

King Books on Fort Street is one of the largest used bookstores in the United States, with close to a million books in its inventory. It has been located in this former glove factory for many years and is a draw to residents and visitors from throughout the United States and the world. The huge graphic glove on the side of the building attracts the attention of passersby.

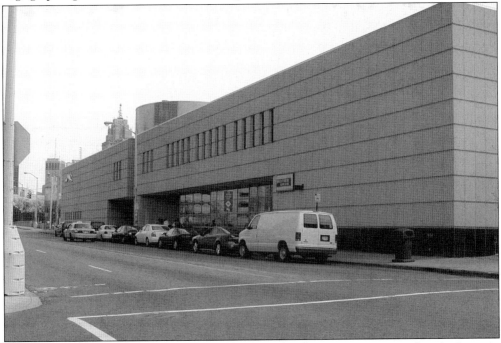

For decades, Corktown has been a transportation hub for the region. Even though the train stations no longer draw travelers, the Greyhound Bus terminal on Lafayette Street continues the tradition. This building will be replaced by a more modern facility on Fort Street.

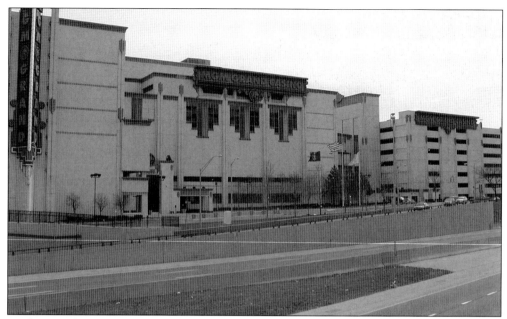

Modern Corktown is now bordered by two of Detroit's Casinos. The MGM Grand (above) is directly across the Lodge freeway along Michigan Avenue while the Motor City Casino (below) is north and east of the neighborhood. Their presence on the fringes of the community has not been intrusive. The casinos continue Corktown's tradition of hosting institutions that are a draw to the southeastern Michigan region.

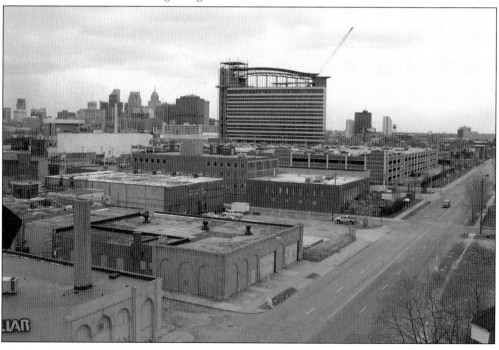

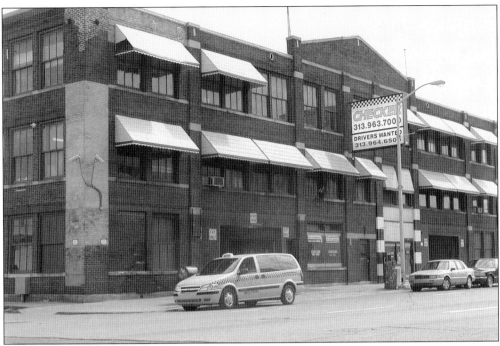

The Checker Cab Company has maintained its local headquarters on Trumbull Avenue for decades. This building has undergone few changes over the years and could be easily recognized by Corktown residents of the 1930s. It sits across Trumbull Avenue from Tiger Stadium.

Eph McNally's restaurant has been serving sandwiches and soups in an old building on Porter Street for several years. This commercial building was constructed in the late 19th century. It has a full bay storefront with a small bay projecting over the corner. The charm of this restaurant contributes to the ambiance of the neighborhood.

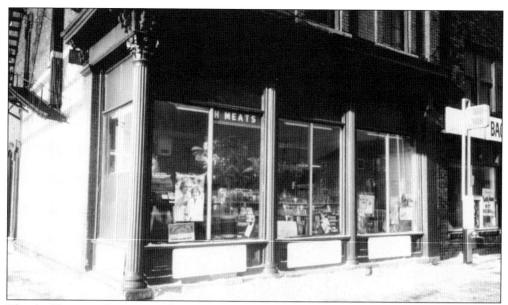

This building on the corner of Trumbull Avenue and Bagley Street is an excellent example of late-Victorian commercial architecture that featured retailing on the ground floor with apartments above. It includes wrought iron columns and metal cornices. There are brick window surrounds and detailing at the cornice line. The two-story addition came later. It still serves as a grocery store for the neighborhood. The picture above shows the market in the 1950s while the picture below was taken in 2007.

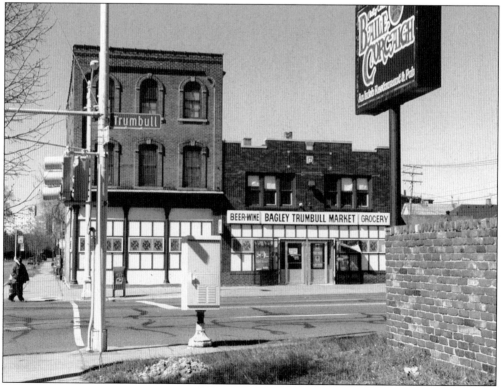

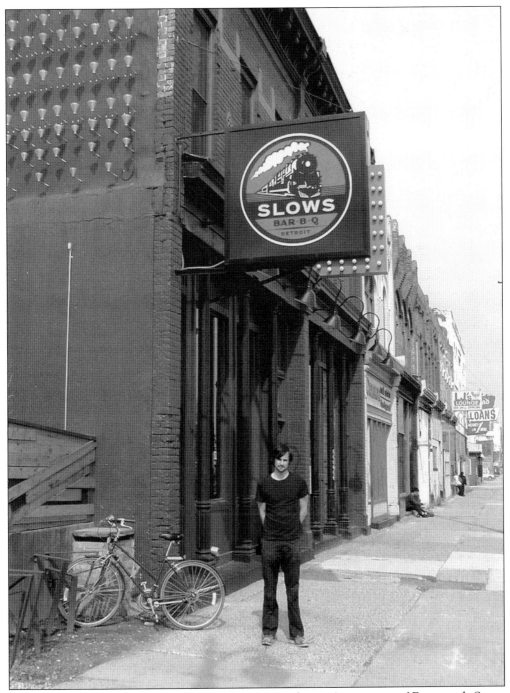

The most intact row of 19th-century buildings on Michigan Avenue east of Fourteenth Street has experienced a rebirth due to the efforts of young entrepreneurs. Pictured here is Phillip Cooley, co-owner of Slows, a hip new restaurant that has become a magnet for people from throughout the region looking for good food and a great atmosphere. Cooley has played a large role in making Corktown attractive to cool Detroiters.

The Corktown Citizens District Council has played an active role in promoting the neighborhood as a great place to live, work, and visit. This postcard is an example of their campaign to make the greater Detroit community aware of this exciting community.

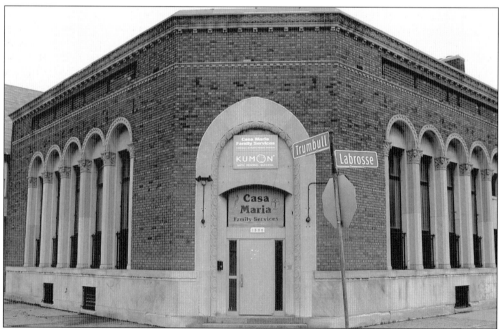

The League of Catholic Woman, many of whom were descended from Corktown's Irish immigrants, established Casa Maria in a bank building on the corner of Trumbull Avenue and Labrosse Street. It served as a settlement house for the many immigrants living in the neighborhood. It continues to serve the community with social programs.

Six

PEOPLE

While a community is often recognized for its setting, monuments, or architecture, its soul comes from the people. Over the nearly two centuries that Corktown has existed, tens of thousands of people have called it home. Some have been born and lived their lives in the community while others have passed through on their way to somewhere else. Corktown has made an impact on all of these people and they, conversely, have made an impact on Corktown.

Lewis Cass, Michigan's first governor, a United States senator, and candidate for the presidency, was the owner of the farmland that was to become Detroit's oldest continually inhabited neighborhood. The Irish immigrants that built their homes, businesses, churches, and institutions include many who have names recognized locally and nationally. In time, thousands of Germans, Maltese, Mexicans, African Americans, and others have settled in Corktown and made their contributions to the city, state, and nation. Thousands of people whose hard work and fortitude led to fulfilling the American dream have called Corktown home. It would be impossible to recognize all of the individuals whose collective lives make up the history of Corktown. Their stories are an inspiration. Their impact is felt throughout the region and nation. The vast majority of the residents of the neighborhood were hardworking people whose values and strong family life have contributed to America's greatness. The individuals featured here represent the thousands of so-called "common people" that have made Corktown's history so inspiring.

Martin Joseph Maloney was a grocer, a politician, and a friend to many people. He was one of old Corktown's most beloved characters. Born in Ireland, he came to Detroit as a boy with his family in 1880. He worked as a grocery clerk as a young man and eventually opened his own store at the corner of Brooklyn and Plum Streets. It became a community center; Martin would find an Irish doctor for the sick or an Irish lawyer for those in need. He founded the Retail Grocers Association to protect the corner grocers against the encroachment of chain stores.

Julia Rouen Hunt was an ambitious young woman whose parents emigrated from Ireland to Detroit and who lived in Corktown and opened a millinery shop on Woodward Avenue. She was a successful businesswoman and opened another shop on Michigan Avenue soon after. In this 1890 photograph, she models one of her creations. (Courtesy of Tom Coles.)

The Rouen family poses for a formal photograph in a park. From left to right are (first row) Eliza and Maurice Rouen; (second row) sons Frank, Jim, John, and Percy. (Courtesy of Tom Coles.)

Prominent Corktowners, the Kerby family had a formal portrait made in the 1890s. From left to right are (first row) Anne, Mary, John, Mary Kerby, and Mamie Driscoll; (second row) Esther, Madge, and Barb Maloney, Eddy Kerby, and Jennie Healy, a cousin. The family moved to Grosse Pointe where Kerby Road was named in their honor.

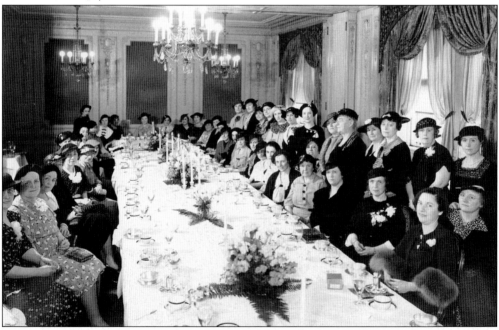

Many young Catholic women in the early years of the 20th century who aspired to go to college were sent to the Sisters of the Immaculate Heart of Mary's boarding school in Monroe. There they were trained to be refined young women. The majority of the women in this photograph of a reunion were raised in Corktown and were of Irish descent.

Fr. Clement Kern was the pastor of Most Holy Trinity Church from 1943 until his retirement in 1977. He became a friend to the rich and powerful as well as the poor and homeless. He dedicated his life to serving the unfortunate in society, and his home and church in Corktown became a beacon to those in need. His humility and tireless work for social justice made him a hero to Detroiters regardless of religion or ethnic origin. Although he died in 1983, his legacy lives on. He is honored with this statue at the corner of Trumbull Avenue and Bagley Street adjacent to the Clement Kern Homes, which are affordable housing that he was instrumental in getting constructed.

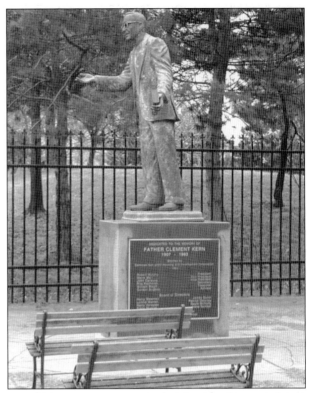

Many members of the Irish community of Detroit continued to consider themselves Corktowners even after they no longer resided in the neighborhood. Pictured above are "Black Jack" Kelley in the cape, a longtime member of the Detroit City Council, and Patrick "Buttons" Mulcahy on the right, preparing to march in the St. Patrick's Day parade in the 1960s.

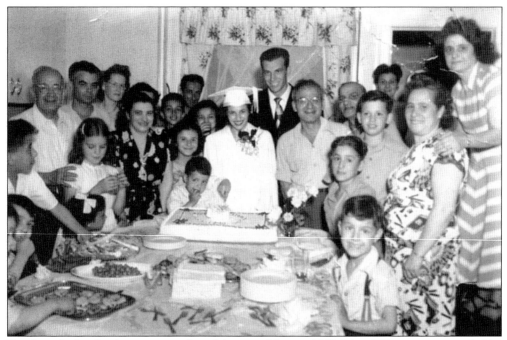

Finishing high school was a cause for celebration. Here in 1949, Mary Tabone is surrounded by her extended family at their home in Corktown on the occasion of her graduation from Girls Catholic Central High School. (Courtesy of Charles and Mary Brincat.)

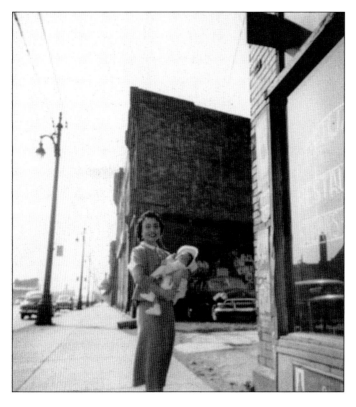

Ofelia Macias is shown holding her cousin Rosalinda Ybarra in front of the Penjamo Restaurant on Michigan Avenue at Brooklyn Street in 1955. Godmother and goddaughter are about to celebrate Ybarra's christening at Most Holy Trinity Church. (Courtesy of Rosalinda Ybarra.)

The ties that bind Corktown residents have lasted for lifetimes. This group of friends that grew up together in Corktown are bound for Malta on a charter flight in May 1974. L. Zahra (second row, center, in stripped shirt) organized the group. He was the vice president of a bank in Detroit. (Courtesy of Charles and Mary Brincat.)

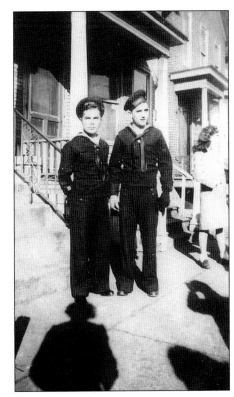

Corktown residents Victor Sultana (left) and Gerry Gale proudly served their country during World War II. They are shown on leave in 1943. Corktown residents of all ethnic and religious groups proudly served their country during times of crisis. (Courtesy of Victor Sultana.)

Henry Ybarra, the young chef on the right, was the executive chef at the Pick Fort Shelby Hotel in downtown Detroit in the 1940s and 1950s. The residents of Corktown made their livings throughout the city in many capacities. Henry and his wife, Carmen, raised their family in Corktown. (Courtesy of Rosalinda Ybarra.)

Henry and Carmen (right) pose for a picture at a family celebration in 1939. The Mexican community of Corktown had grown steadily during the 20th century. (Courtesy of Rosalinda Ybarra.)

Going to mass at Most Holy Trinity Church on Easter Sunday was a time to dress up. Phillipe and Alicia Medina pose with their son Gilbert on Beech Street in 1944. Holidays were a special time in Corktown. (Courtesy of Rosalinda Ybarra.)

This mother is helping her daughter prepare for her *quinceanera*, her 15th birthday celebration. Detroit's Mexican community has grown rapidly and is now centered further west along Vernor Highway. (Courtesy of the Detroit Public Library.)

These young men, members of the St. Vincent High School football team in 1945, forged bonds that have lasted a lifetime. Their names are a good indication of the cultural diversity that was characteristic of Corktown in 1945. Included in this photograph are Larry Porte, Charles Brincat, Fernando Ramierez, Larry Bonnici, Robert Wiley, John Muliett, Georg Vessells, David Mansoor, Jack Fitzpatrick, Eddie Urban, and No. 35 is Art Barballa. (Courtesy of Charles and Mary Brincat.)

Merry Christmas

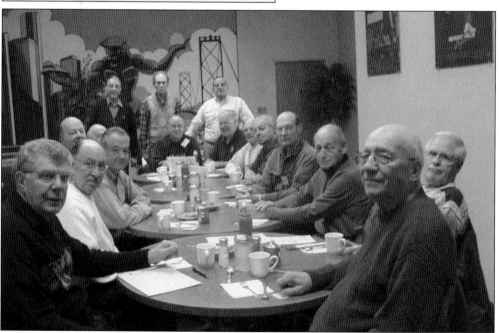

These gentlemen, most of whom grew up in Corktown and are graduates of St. Vincent High School, gather on a regular basis for breakfast in the old neighborhood to talk about old times and maintain lifelong friendships with the "old gang." Many of them were members of the St. Vincent High School football team in their youth.

During the early 1940s, as World War II was being waged in Europe and Asia, millions of Americans were serving their country. These young men, from left to right, are Joe DeBono, Vincent Gale, and Charlie Zammit. They had a brief reunion while home on leave from various branches of the military. (Courtesy of Victor Sultana.)

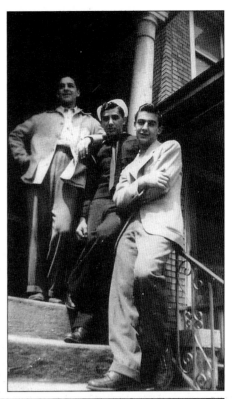

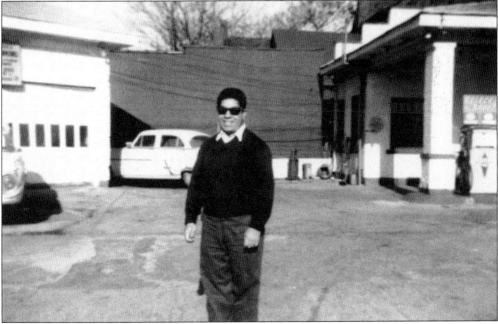

This young man, Moses Venegas, owned the Sunoco gas station on the corner of Fifth Street and Vernor Highway in the 1960s. Young entrepreneurs like Venegas provided the services that Corktown residents needed. This station was demolished to make way for the Fisher Freeway shortly after this picture was taken. (Courtesy of Rosalinda Ybarra.)

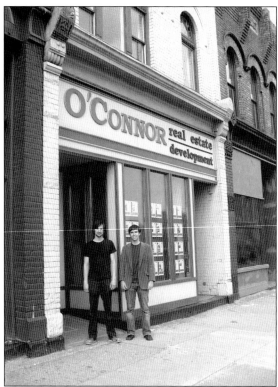

Phillip and Ryan Cooley are two brothers that have come to Detroit after living in other states in order to play a role in the creation of a cool, urban landscape. They own O'Connor Realty and Development Group, pictured here, and are involved in adaptively reusing buildings in Detroit. Their efforts have resulted in an increased excitement about Detroit's renaissance and have had a pronounced impact on Corktown. While not from Corktown, their Irish ancestors would be very proud of their efforts.

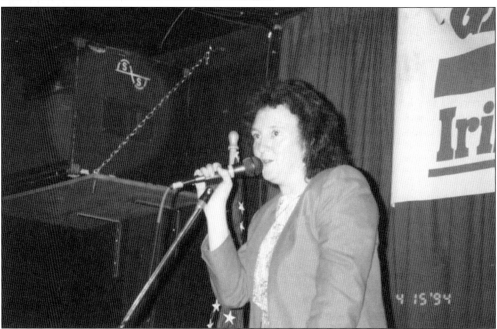

Kathleen Dewan O'Neill is shown behind the microphone while she broadcasts the Irish Radio Hour, as she does every Sunday afternoon. She plays Irish music, announces current events in the Irish community, interviews visitors from Ireland, and is very active in keeping the community together. She often broadcasts from the Gaelic League in Corktown.

Seven

SALOONS

In both Ireland and America, the Irish pub has served many purposes besides its traditional one as a place where alcohol is served. At various times, it has been a meeting hall, a political caucus room, a church, a concert hall, and a schoolroom. Of even more significance, however, is the role the pub has served as a place where people can talk with each other, sometimes about the most important issues of the day and sometimes about matters of complete insignificance. More important than the beverages or food that is served is the camaraderie that comes from the public forum and community center that these institutions provide their patrons.

Whether called bartender or publican, the barman or barwoman is far more than a person who dispenses alcoholic beverages. At times he or she is called upon to be an advisor, a counselor, a teacher, or simply an individual who lends a friendly ear when needed. There have been a few who have served almost like mayors in their little communities, and there have been some that can lead a group conversation with the skills of a symphony conductor.

Corktown has been blessed with a number of pubs, many of which are decades old, while others have only a few years of existence. The tradition of the public house serving as a neighborhood gathering place has continued into the 21st century with new Irish as well as non-Irish bars and restaurants opening on a regular basis. These establishments serve as a gathering place for the residents of Corktown and also draw their regulars from throughout the region.

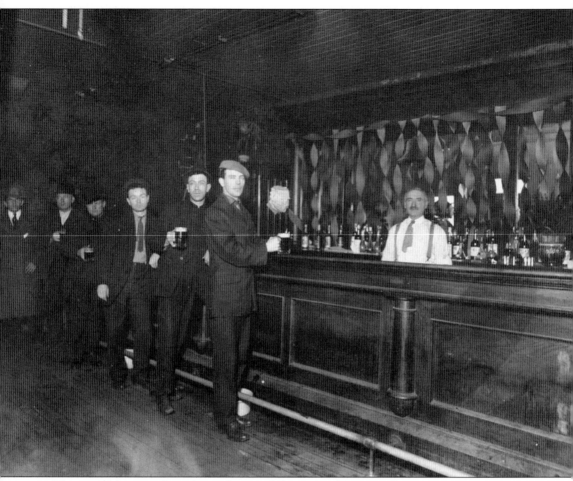

Thomas Maloney's saloon, located on Twelfth Street, was originally a grocery store. It became a pub when Maloney bought it, and it remained one until Prohibition became law in Michigan in 1918. At that time, he turned it back into a grocery store, which it remained until he retired in 1925. Maloney is in shirtsleeves bartending. His son David is on the extreme left along the bar.

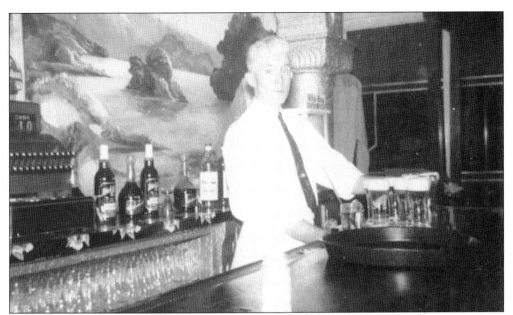

In 1933, with the end of Prohibition, Billy Walsh opened his little pub at Henry and Harrison Streets in a corner of Corktown. He served a loyal clientele for almost 20 years. It was said to be almost as good as a church for finding out what was going on in the neighborhood. In the 1950s, Walsh could not convince the state and city planners not to run a new freeway through his part of Corktown, and his place was closed and torn down. Pictured above is Walsh behind his bar. Below is a painting of Walsh's Bar by John Coffey, a man-about-Corktown and painter of local fame. (Below, courtesy of Dee and Kerran Ryan.)

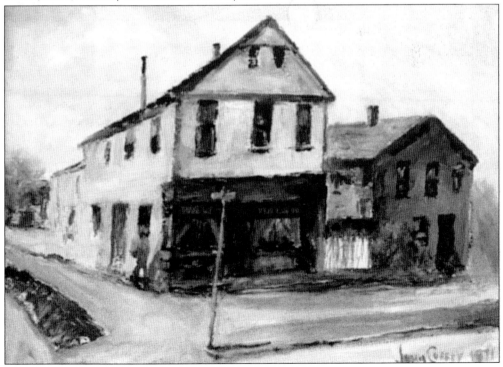

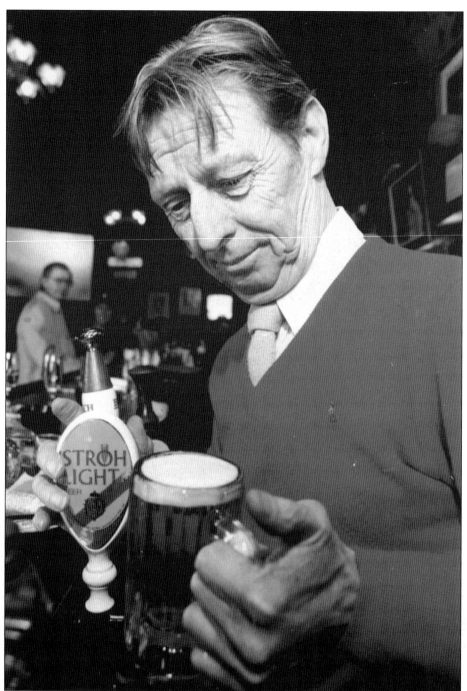

Over the 40 years that Nemo's Bar has been in Corktown, it has evolved into a sports bar with a wealth of sporting memorabilia, wonderful pub food, and a very loyal Irish clientele. Tim Springstead, the current owner and son of Nemo, keeps a dictionary and a baseball encyclopedia on top of the bar to help settle disputes. Pictured is Jimmy Scott, longtime manager and bartender, as he pulls a local brew. Scott was born on Labrosse Street in the childhood home of his mother, Mary Farrell Scott, and spent most of his life in Corktown.

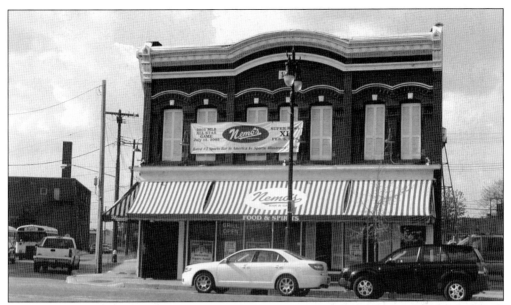

Nemo's Bar on Michigan Avenue and Eighth Street is an authentic Irish pub, complete with tin walls and ceiling, a hardwood bar, and a picture of its founder, Nemo Springstead, presiding over it all. The building has housed a bar since the 1920s and even included a bowling alley. Springstead and his wife, Virginia, purchased the bar in 1965 and it has remained in the family ever since. Through the years, some of Detroit's most colorful barmen, including Patrick "Buttons" Mulcahy and Jimmy Scott, have served customers here.

Baile Corcaigh means "town of Cork" in Gaelic and signals a return to the Irish roots of Corktown. Opened in 2005, it sits on the former site of the Catholic Workers Movement headquarters. The previous structure on the site was demolished in the 1950s and a plain bar was opened to serve baseball fans. After extensive remodeling, Sharon Mooney Malinowski and her husband, Leo, opened an authentic Irish restaurant that draws diners from throughout the region.

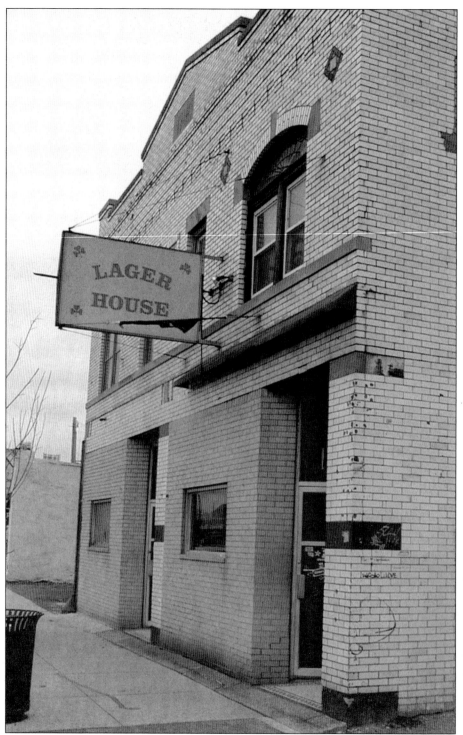

The Lager House is one of the last surviving buildings in its row on Michigan Avenue. For many years, it has been a saloon or bar. It has transformed itself several times in its history and is still a bar and includes a performance space that showcases hip new bands in the Detroit area.

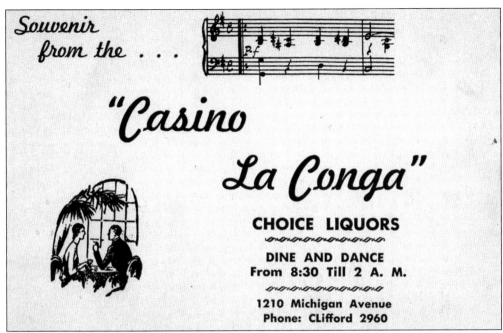

Souvenir from the . . .

"Casino La Conga"

CHOICE LIQUORS

DINE AND DANCE
From 8:30 Till 2 A. M.

1210 Michigan Avenue
Phone: CLifford 2960

Corktown's tradition of watering holes that attract Detroiters has not been limited to Irish pubs. A number of clubs catering to the large Hispanic community have also existed in the neighborhood. The Casino La Conga on Michigan Avenue was a popular dining and dancing spot for a number of years. (Courtesy of Rosalinda Ybarra.)

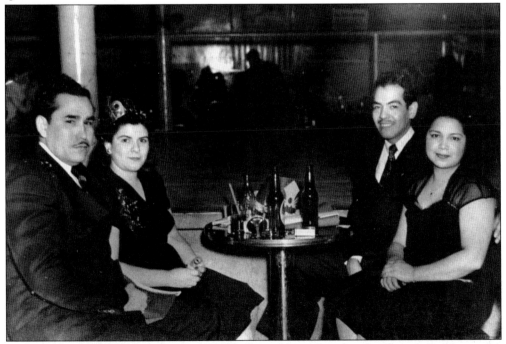

These young couples are relaxing on a Saturday night with a few drinks and dancing at the Casino La Conga. In the 1950s, a night out meant dressing up and heading out with friends to a favorite nightclub. (Courtesy of Rosalinda Ybarra.)

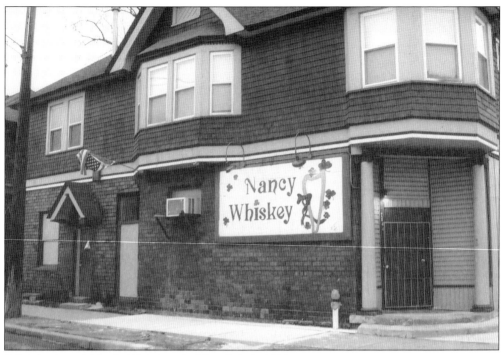

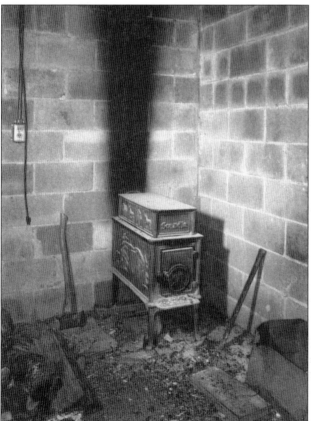

In 1986, Nancy McNiven and Owen McCarthy bought the bar located on Harrison Street in North Corktown. The building had housed a bar since at least 1902 and retains the tin ceiling and a solid mahogany bar. Except for the large sign on the side of the building (above), the bar blends into the residential neighborhood. While investigating a gas leak in 2000, what McNiven thought was an old stove in the basement (at left) turned out to be a vintage still. Nancy Whiskey epitomizes the Corktown pub of a century ago as it continues to draw loyal patrons.

Eight

ARCHITECTURE

As Detroit's oldest extant neighborhood, it is not surprising that Corktown architecture reflects many styles and that the rich legacy of the inhabitants has been preserved to the benefit of both the community and the entire region.

Predominantly a working-class community, Corktown does not have many residential monuments like other Detroit neighborhoods such as Brush Park and Indian Village. Nonetheless the architectural styles found in the neighborhood delight the senses and have been consistently maintained over the years. Thousands of people have toured Corktown each June since the home tour committee of the Corktown Historical Society began the Corktown Home and Garden Tours in 1986.

The residential architecture of Corktown reflects the working-class inhabitants who founded the community in the 1830s. Most of the houses were built from lumber that was still abundant in Michigan in the 19th century. The oldest structures were usually built on wooden piles without basements. Some of the original houses were refined log cabins. As construction technology improved, buildings in the neighborhood became more stylish. Since the community was not wealthy, most homes were built of wood rather than brick or stone and architects were rarely employed to design elaborate buildings.

The most common early houses were referred to as "shotgun houses," because they were built on narrow lots, and a shot fired in the front of the house would theoretically pass through each room on its way to the back. In Detroit, the houses were also known as workers' cottages and Irish cottages.

Prior to the Civil War, the most popular style of architecture in the United States was classical revival, also referred to as Greek Revival and Colonial Revival, and many houses in Corktown feature pillars, triangular pediments, and arches in their facades that reflected this trend.

After the Civil War, new styles became popular. Gothic Revival architecture introduced romantic decoration reminiscent of medieval Europe. Pointed arches replaced rounded ones and decorations and colors were very ornamental. Italianate and Queen Anne houses became popular and are found throughout Corktown. Leverette Street is lined with many surviving houses built in this style.

Corktown has been one of the most successful Detroit neighborhoods in preserving architectural heritage. Despite the tragic attempt to convert the neighborhood into an industrial park in the 1950s, much of the neighborhood has been preserved and renovated. The latter years of the 20th century witnessed the redevelopment and adaptive reuse of many structures into homes and condominiums, and new housing has provided reasonably priced homes for working-class residents while maintaining the character of the neighborhood. The Father Kern Homes on Bagley Street provide attractive living for low-income residents as well, making Corktown one of the most economically and ethnically integrated communities in Michigan.

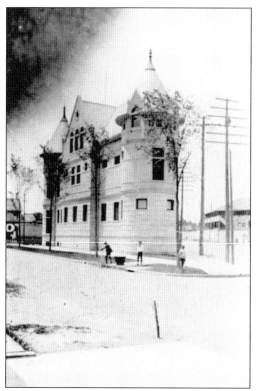

This old castlelike building was the police station at Trumbull and Michigan Avenues until the widening of Michigan Avenue in the 1930s. It was built to resemble a feudal castle and provided police protection to Corktown for many years. It was diagonally across Trumbull Avenue from Briggs Stadium and provided police protection to the ballpark and the neighborhood. (Courtesy of Michael Clear.)

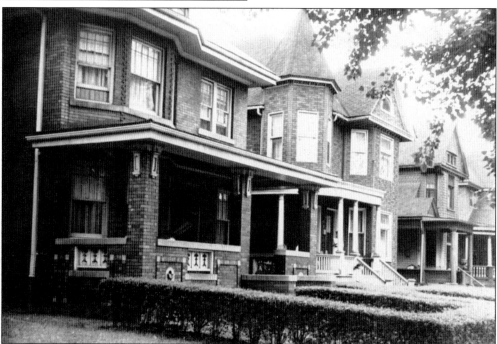

These houses on Leverette Street were photographed in 1950. They escaped the demolition that occurred in other areas of Corktown and look remarkably similar today because of their regular maintenance. (Courtesy of Mary Luna Abbott.)

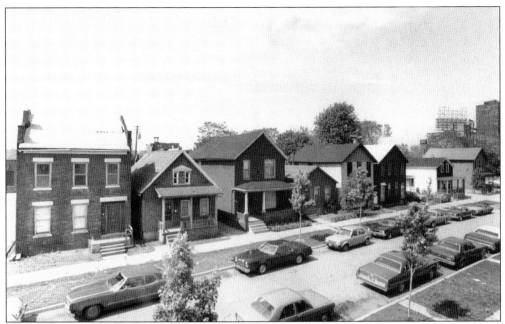

Much of Corktown of the 1950s has disappeared through demolition. Despite the assault on the community from officials who were determined to save the city by destroying its past, many buildings and streetscapes remain. The picture above was taken on Labrosse Street between Eighth and Brooklyn Streets in the 1950s. This street escaped the destruction and appears quite solid in the picture taken below in 2007. (Courtesy of Michael Clear.)

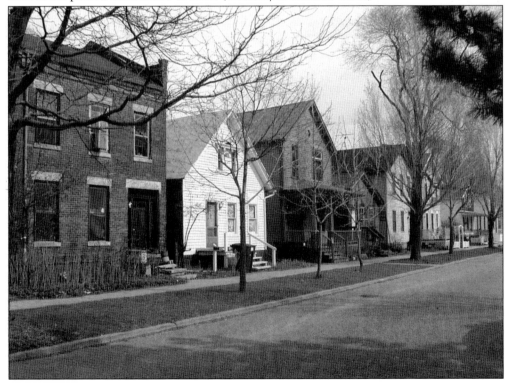

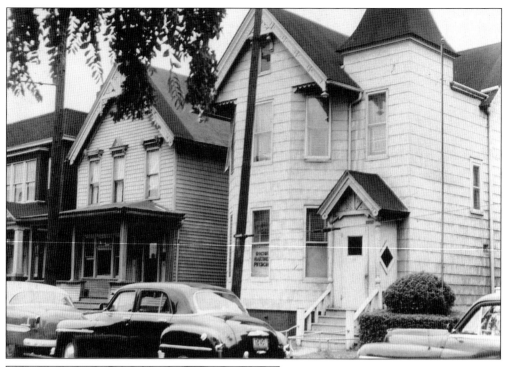

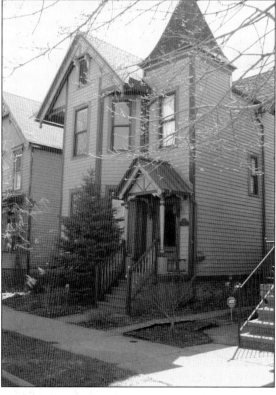

Carpenter Edward Dobson built this house at 1439 Bagley Street in 1867 to serve as a rental property while he lived next door. The porch and the columns are Italianate while the cornered dome adds an interesting architectural dimension to the house. The top photograph shows the house around 1950, and the one at left was taken in 2007. As with many houses in Corktown, the restoration has been very sensitive to the original appearance.

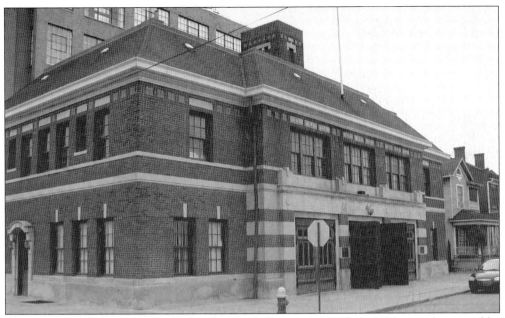

The firehouse at the corner of Bagley and Sixth Streets was built in 1918 to replace an older station constructed in 1873. It was decommissioned in 1981 because it had become obsolete. The city sold it in 1982 to a law firm with the condition that it be adaptively reused. The exterior of the building looks much the same as it did in the past but the interior has been transformed into a modern office.

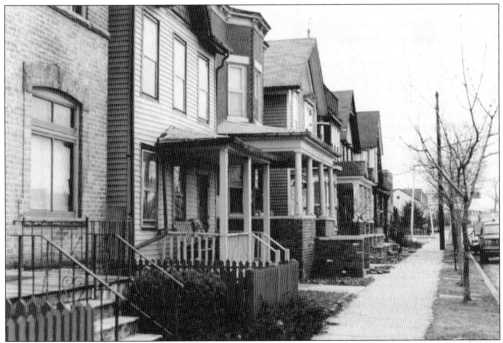

Unique among Detroit's oldest neighborhood is the streetscape. All of these buildings on Bagley Street were built in the 19th century and are still occupied. Neighborhood pride is one reason that Corktown has survived when so many other neighborhoods have not.

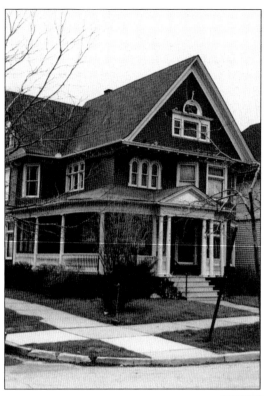

Corktown's largest private house is a Colonial Revival specimen that was built in 1893 for Helen McKerrow, a school principal. Located at 1670 Leverette Street, its Palladian gable windows and slender paired Doric columns and wraparound porch make this a beautiful example of Victorian-era architecture. For many years, Ethel Claes ran a secondhand bookstore in the house. Claes is credited with galvanizing Corktown residents to fight the urban renewal that cleared so much of the neighborhood in the 1950s.

One of the rare surviving apartment houses in the community, this building on Porter Street was constructed in the 1920s. It has a simple design with a courtyard entrance that makes it stately. It lends its charm to the block.

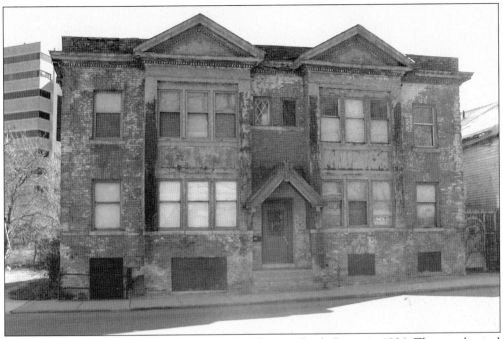

Boyd McKay built this four-unit apartment building on Sixth Street in 1906. The neoclassical style of the building sets it apart from many of its neighbors. The current owner is a descendant of McKay and is renovating the apartments for rental.

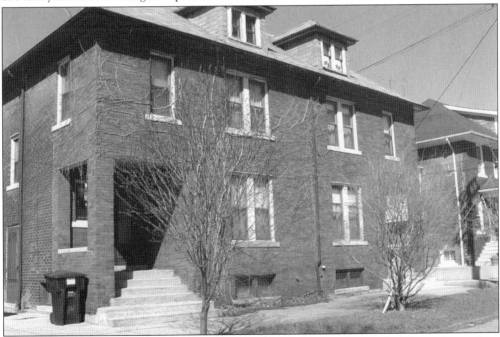

Built in 1913, this is one of the newest of the old houses in Corktown. It reflects the modern trend in residential construction in the early 20th century. The side-by-side duplex, although fronting Eleventh Street, was built on the back lot of a house on Leverette Street at a time when the city's population was rapidly increasing.

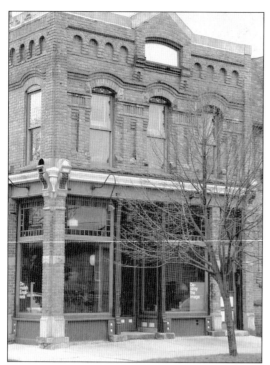

Hugh L. Gamble erected this Victorian building at the corner of Bagley and Eighth Streets in 1887 to house his meat market on the ground floor and his family in the apartment above. After he died, it housed a flower shop, other retail, and the offices of the Tiger Stadium Fan Club. In 1995, it was purchased by architect Brian Hurttienne who restored the apartment for himself and the ground floor for his office.

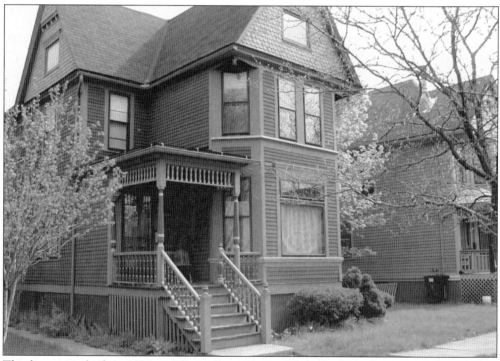

This house was built in 1896 on Cherry Street west of Tiger Stadium. It was moved in 1985 to its present location at Bagley and Brooklyn Streets by the Corktown Citizens District Council along with two other houses that are now adjacent to it on Bagley Street. Its many colors reflect its status as a "painted lady" from the Victorian era.

The Church House is named after the family of Elijah M. Church who built it in 1863. There is Italianate detailing on the facade of this house that adds a special attraction to it. Note the large fixed-floor window flanked by narrow double-hung windows. The transom over the front door was originally inscribed with the address. Once a flower shop, it is now a residence that graces Bagley Street.

This Italianate house is a duplex. While not as ornate as some other houses in the neighborhood, it has a stately demeanor that it has maintained for over a century. Bagley Street has some of the oldest houses in the neighborhood.

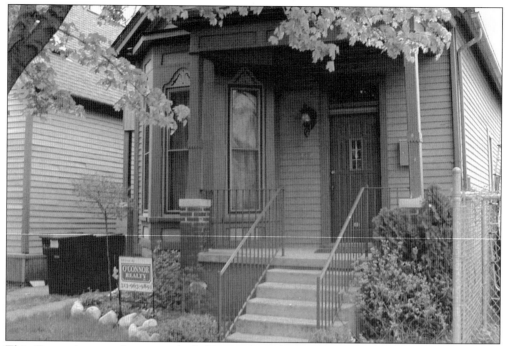

This Queen Anne–style, one-and-a-half-story frame house at 1414 Bagley Street was first listed in the city directory in 1887. Charles Kitchen, the original owner, was a travel agent and a contractor who lived in the house with his family until 1918.

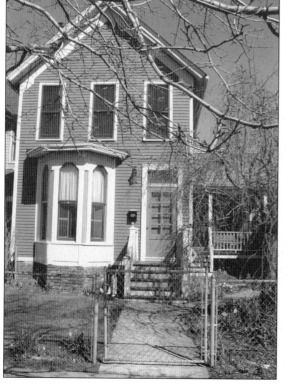

Like others on this block of Bagley Street, this two-story frame house has several Italianate features, including an elongated window, oculus in the gable, and a bay window with angular corners at the upper sash. It is an attractive addition to the streetscape.

The Mason House was built in 1862 for Detroit brewer John Mason. This is one of only five brick vernacular Greek Revival townhouses left in Detroit. It consists of a high basement, regularly arranged windows, stone lintels and sills, an entrance surmounted by a transom, and side lights. The brick exterior is relatively uncommon in Corktown. The house presides over its corner of Sixth and Bagley Streets.

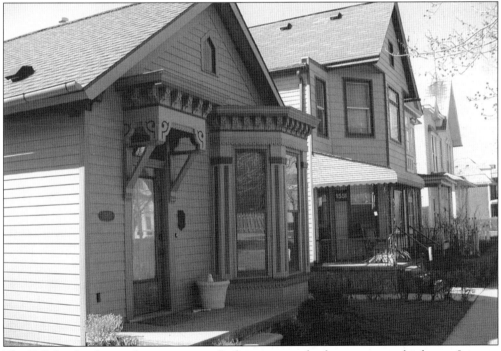

The Kelleher brothers, saloon owners in Corktown, were the first to occupy this house. It seems to have originally been a shotgun house that was later remodeled with Italianate details around the windows and porch that added a stately feel to the facade. It is located on Leverette Street.

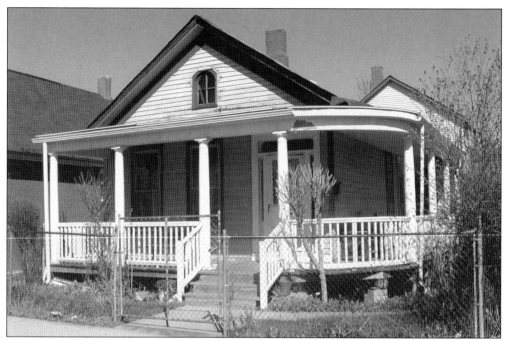

This house was probably built in the 1850s as a traditional worker's cottage. By the 1890s, the owners probably wanted to upgrade and added the wraparound porch that was more characteristic of the Victorian style of the time.

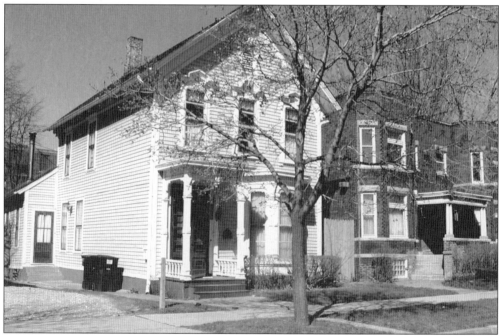

Joseph H. Easterling, a carpenter and contractor of Prussian heritage, built this house on Wabash Street in 1864. His family resided here until 1954. This house is one of the finest examples of an Italianate-style residence. Note the eyebrow window hoods, the small eaves brackets, the elongated columns of the porch, and the rounded panes of the front bay window.

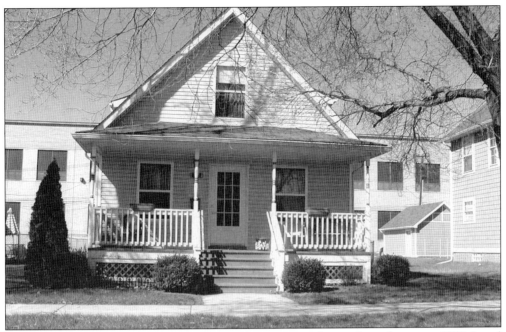

The Corktown Consumer Housing Cooperative constructed several new houses in 1998. Local architect Steve Flum designed these one-and-a-half-story updated versions of the worker's cottages on Wabash Street that are so common in Corktown. New housing in Corktown has attempted to mimic the traditional styles built in the 19th century.

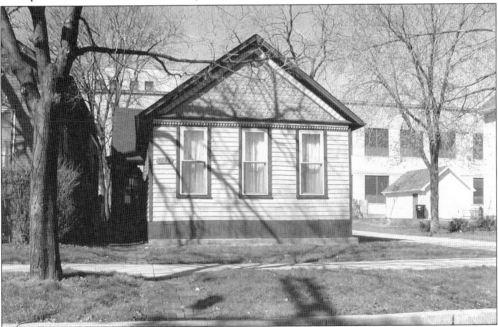

This worker's cottage was built in 1864 and is typical of the small homes in the neighborhood except that there is no door to the street. It is situated on the side leaving a clean, simple facade. The triangular gable is covered with shingles giving it a little ornamentation. It is located on the western edge of Corktown on Wabash Street.

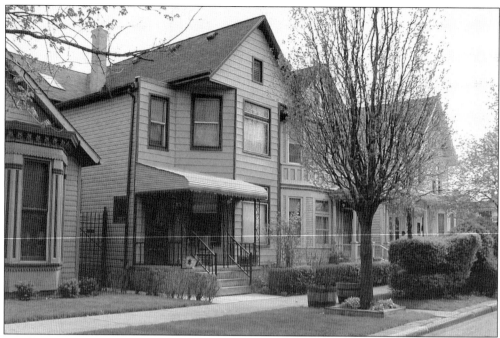

Engelhart Maltz built this house on Leverette Street in 1859. At some point in its history, the house was updated to its present Queen Anne–style appearance. In 2003, a fire next door caused extensive damage. The current owner has restored the house to pristine condition.

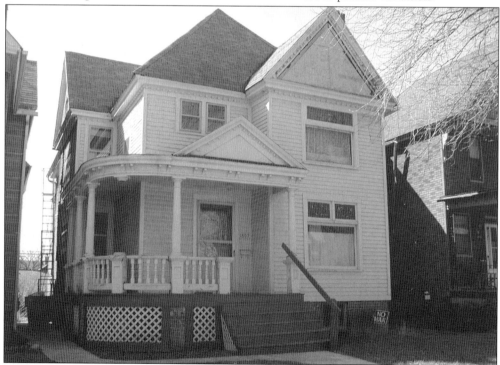

Sometime between 1882 and 1885, this house was moved to its present site on Leverette Street. It stands out because of the impressive circular porch on the front and side.

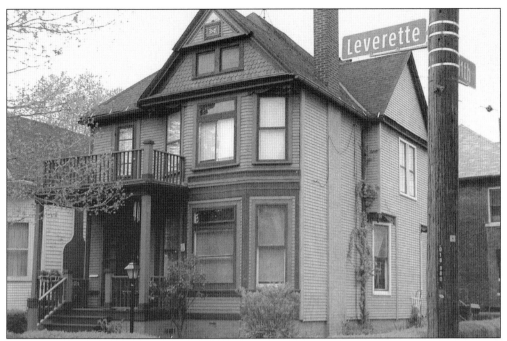

Detroit grocer George Goudie built this vernacular-style home on Leverette Street in 1893 with classic and Queen Anne elements. Originally a single-family house, it was split into two units, as was often the case in Corktown in the early part of the 20th century.

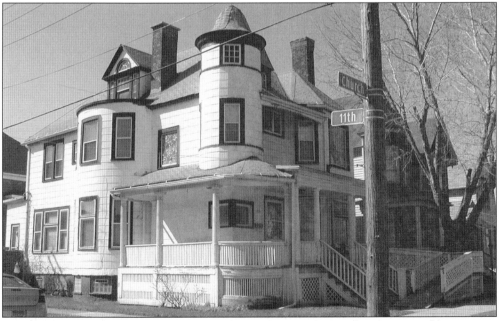

This Victorian house was resided in the 1940s and stripped of its detailing in order to appear more modern. Among the interesting detail are the wraparound porch, the turret, dormer, and the two-story bay. It is one of the more elaborately detailed houses in Corktown. Leverette Street was developed several decades after the eastern portion of Corktown and thus reflected the taste in Victorian that was popular late in the 19th century.

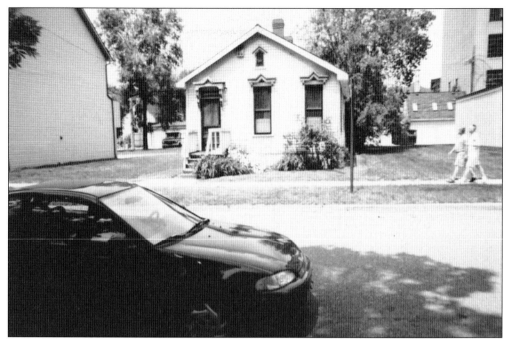

This is an example of a shotgun house on Labrosse Street that was built in 1851. Sometime later, the Italianate details were added. These include the bracketed window hoods and the elongated windows in the front. Originally built on cedar posts, it has since been set on concrete piers.

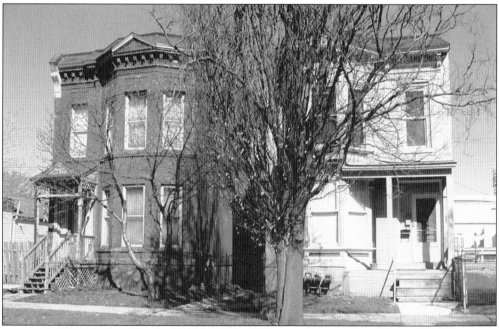

These two Victorian buildings are detached row houses. In cities along the Atlantic seacoast, they are usually attached, but with Detroit's flat expanse, it was economically possible to separate the buildings. Although a majority of Corktown's residences are built of wood, these are distinguished by their brick exterior.

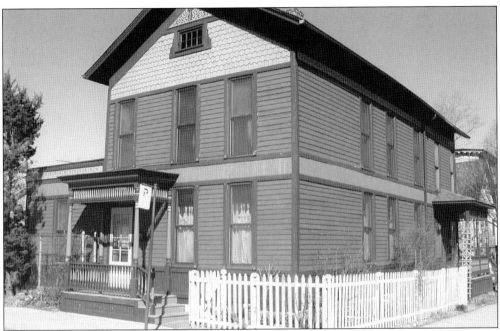

This is one of the oldest houses in Corktown, situated across Sixth Street from Most Holy Trinity Church. Its clean facade shows that it predates the Italianate decoration that was more common for neighborhood houses built after the Civil War. The house has been beautifully restored, and the garden is a pride of Corktown.

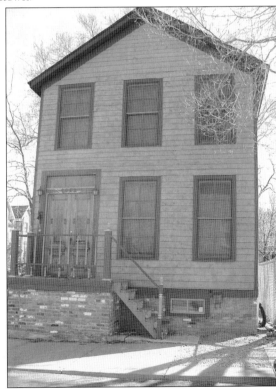

This mid-19th-century vernacular house on the corner of Brooklyn and Eighth Streets was one of the few houses in Corktown actually designed and built by an architect. Almon C. Varney was a popular architect and contractor. The house is a simple design with especially beautiful front doors.

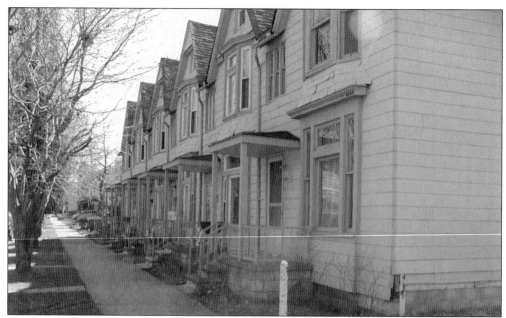

This row house was built in 1895 by carpenter E. Howell on Leverette Street and Twelfth Street (now Rosa Parks Boulevard). It is very unusual to find wood-frame construction row houses from the early 20th century because they were often destroyed by fire. The repeating gables indicate each unit and there is decorative Queen Anne detailing such as the projecting bay windows on the second story.

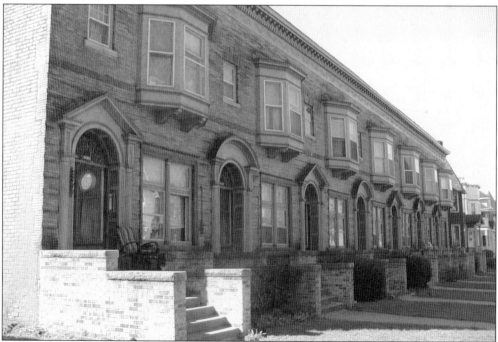

In 1875, this row of seven brick units was constructed in the Colonial Revival style. There are interesting details such as the alternating segmental and triangular pediments above the entrances. They blend nicely with the single-family homes that predominate on Leverette Street.

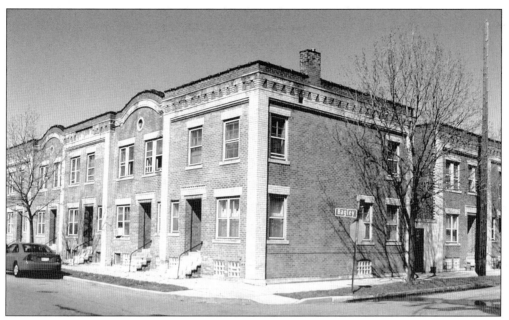

These townhouses consist of two buildings, one on Bagley Street and the other on Tenth Street. Notice the arched cornices with oculus windows in the attic flanking a central unit exhibiting the building's name, Beyster Terrace. The use of orange brick with gray brick masonry is unique. While the units were subdivided during the enormous growth of the city in the 1920s, they were returned to their original plan in the 1970s.

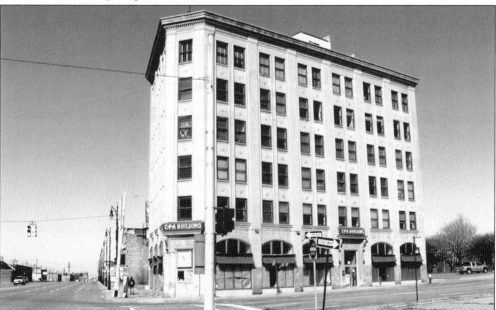

When this office building was constructed in the early 20th century at the corner of Michigan Avenue and Fourteenth Street, it became the pride of the neighborhood. It originally housed offices and was one of the few commercial office buildings that were built west of downtown. There are Gothic touches in the cornice and around the lower windows. It is an example of collegiate commercial architecture.

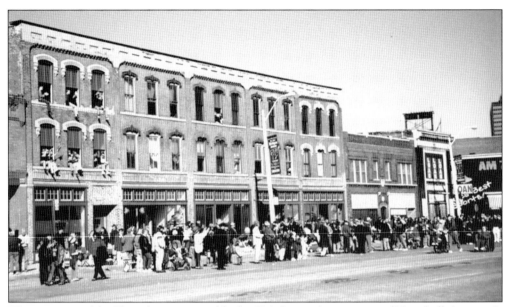

This commercial building dominates its block of Michigan Avenue east of Trumbull Avenue. It was constructed in 1882 with five storefronts and apartments above. Note the patterned brickwork and the ornamental window hoods. In 1927, the upper floors were altered to become a 40-room rooming house. It was restored in the 1990s by owners Brian Brincat and Joe Mifsud to rental apartments. It provides an excellent viewing point for the annual St. Patrick's Day parade.

The Corktown Industrial Park included these two high-rises built by the State of Michigan to house the state offices in southeastern Michigan. By 2001, the state agreed to move its local offices to the 1920s former General Motors Building and left these 1960s building vacant. It is expected that they will be demolished and replaced by the local offices of the FBI.

In the 1950s, the city tore down all the buildings bounded by Trumbull Avenue, Porter Street, LaBrosse Street, and Twelfth Street so the IRS could build a data center. When it was built elsewhere, the land remained vacant until the early 1970s when the Holy Trinity Non-Profit Housing Corporation was formed and built these affordable row houses on the site.

This row house on the corner of Brooklyn and Labrosse Streets was built in the mid-1990s and simulates traditional colonial architecture. It blends nicely with the century-old buildings surrounding it. The two-story turret on the corner is a beautiful feature.

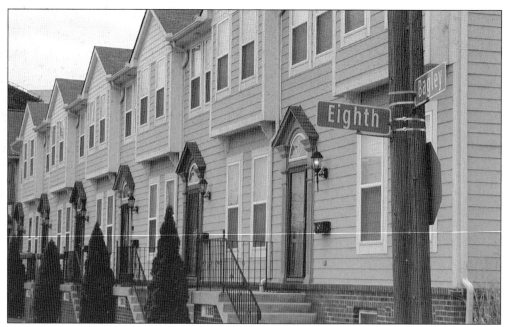

The lot this six-unit attached townhouse sits upon was formerly a 1950s one-story manufacturing building that was in the middle of a residential stretch of Bagley Street. Mexican Industries relocated to an industrial park with the assistance of the Corktown Citizens District Council, and this condominium development replaced it. It is sensitive to the architecture of the block and has fit in harmoniously. The interior has a contemporary floor plan while the exterior is traditional.

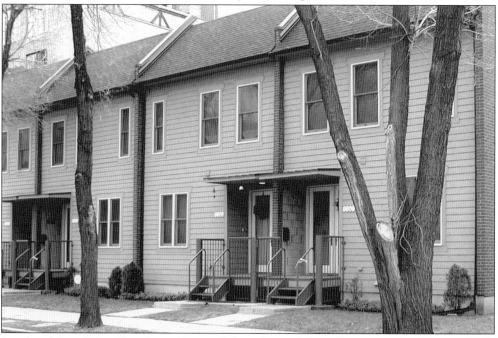

Local architect Brian Hurttienne designed these four side-by-side units so that they would fit into the neighborhood despite their modern construction. The Federal style is comfortable with the older houses on Bagley Street without being obtrusive.

A number of strategies were employed to stop the demolition in the neighborhood and to reverse the trend toward abandonment, especially in the North Corktown community north of the Fisher Freeway. This house is one of a number designed by Brian Hurttienne based on the local vernacular architecture. It and others were designed to restore the feel of the traditional neighborhood.

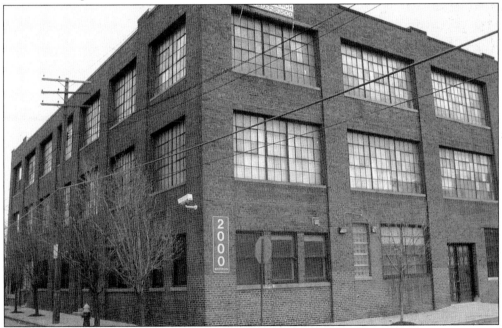

During the early years of the 20th century, many small industrial buildings were constructed to serve the rapidly growing city. This factory was purchased in the late 1980s and transformed into working and living space for artists. Approximately 14 artists currently call it home. Their presence has contributed to the appeal of Corktown as an exciting urban community.

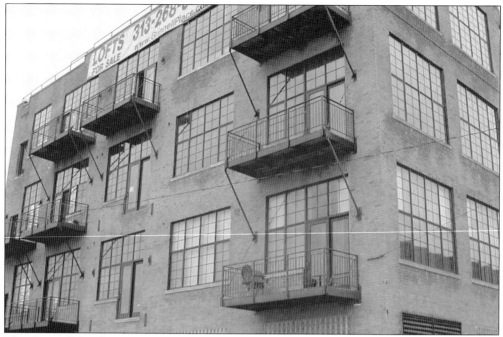

The Grinnell brothers, Ira and Albert, opened piano stores in Ann Arbor and Detroit. They built this warehouse in 1921 to use as a workshop for their stores. Capitalizing on the trend to turn old buildings into trendy condominiums, this building has become a sought-after address in the 21st century.

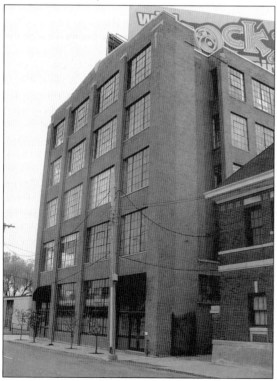

An excellent example of 20th century modernism, the Westinghouse Building was converted to condominiums in the mid-1990s. Standing on the corner of Sixth Street and Bagley Street, it was one of the first of the industrial buildings converted to residential use in Corktown. It combines Victorianism and modernism with full bay windows and streamlined systems with minor Beaux-Arts detailing.

Nine

WORKER'S ROWHOUSE MUSEUM

During the 1850s, a small row house was built on Detroit's Sixth Street to house the rapidly increasing population of Irish immigrants. It was a simple frame house built with the still-abundant lumber available in the region. No luxurious amenities were included. There was no doubt the house would be home to working people who would need to work hard in order to survive.

Originally it consisted of three, 560-square-foot, two-story units, not much smaller than many of the one-story shotgun houses being constructed in Corktown during the same period. Over the years, the middle unit was altered and its door was covered over. No one knows for sure the exact year that it was constructed.

Immediately north of Most Holy Trinity Church, the building has always been home to poor and working-class people that have lived in Corktown. Originally inhabited by Irish immigrants, it has been home to people of many different ethnicities over the 150 years of its existence. As such, it was chosen by the Greater Corktown Development Corporation in 2003 to become a museum dedicated to honor the lives of the mass of immigrant families that have lived in the neighborhood since the 1840s. Their toil made the city a strong center for the dignity of labor and the struggle to improve the living conditions of the working class in the region, the nation, and indeed, the world.

Fund-raising began in the early 21st century with a goal of building the Worker's Rowhouse Museum on the site. It would highlight the living conditions and daily life of residents of the building from the 1850s through the 1930s. When completed, people, especially the young, will learn how their ancestors lived, worked, worshiped, were educated, and socialized through displays, markers, and lectures. The museum will honor the people who made the American dream a reality through their hard work and grit.

The Worker's Rowhouse Museum is to be housed in this building, shown here in the early 1950s. It is one of the oldest buildings in Detroit and has been inhabited by many people during its long history. By the year 2000, it had become worn-out but had the potential for renovation. (Courtesy of the Greater Corktown Development Corporation.)

By the end of the 20th century, the old building was showing its age and its future had become questionable. The Archdiocese of Detroit, the latest owners of the property, agreed to donate it to the Greater Corktown Development Corporation as the site for the museum. This picture shows it just before renovation began.

The board members of the Greater Corktown Development Corporation and other volunteers relax after a Corktown house tour in 2007. Their hard work and dedication result in Corktown's continued success. (Courtesy of the Greater Corktown Development Corporation.)

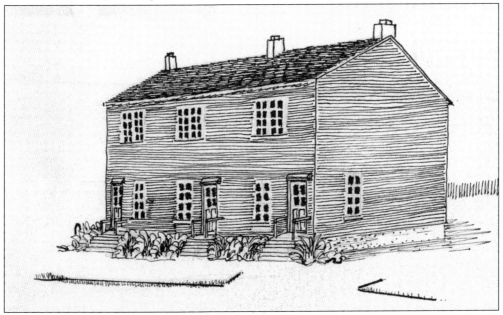

This drawing shows how the Worker's Rowhouse Museum will look upon completion. It will draw visitor from across the state, the nation, and, in fact, the world. (Courtesy of Margaret O'Leary Demery.)

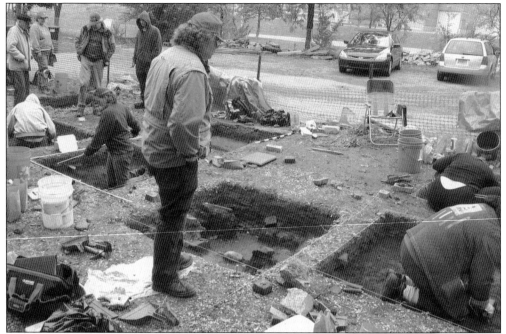

As part of the restoration, an archaeological dig was arranged by the Wayne State University anthropology department. Pictured above are Gregory Young in the center foreground and Celeste Belanger behind him with other students digging for items from the past. Below is a photograph of a pipe stem from Montreal made by Hendersons Pipe Company found by the diggers. It is dated between 1847 and 1875. (Courtesy of Dr. Meghan Howey.)

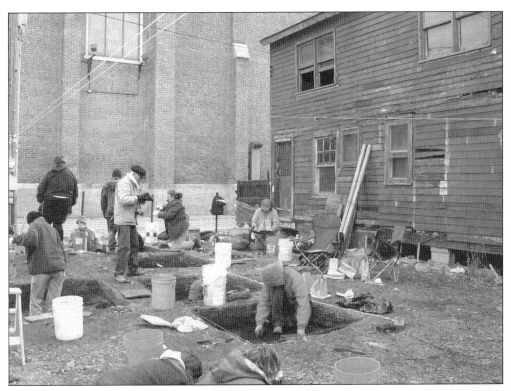

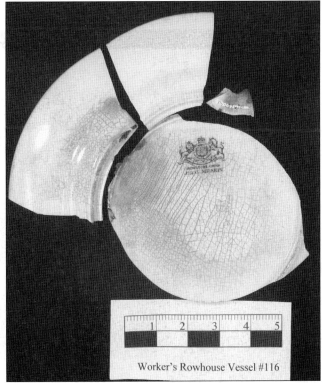

The restoration of the row house provided students from Wayne State University and Cass Technical High School with the opportunity to participate in the search for artifacts from the past. The photograph above shows the students and their leaders digging for buried treasures. At right is an example of their findings. It is a fragment of a piece of pottery imported from England made by J. and G. Meakin Pottery. All items discovered on the property will be displayed in the museum. (Courtesy of Dr. Meghan Howey.)

Worker's Rowhouse Vessel #116

ACROSS AMERICA, PEOPLE ARE DISCOVERING SOMETHING WONDERFUL. THEIR HERITAGE.

Arcadia Publishing is the leading local history publisher in the United States. With more than 3,000 titles in print and hundreds of new titles released every year, Arcadia has extensive specialized experience chronicling the history of communities and celebrating America's hidden stories, bringing to life the people, places, and events from the past. To discover the history of other communities across the nation, please visit:

www.arcadiapublishing.com

Customized search tools allow you to find regional history books about the town where you grew up, the cities where your friends and family live, the town where your parents met, or even that retirement spot you've been dreaming about.